# WORLD
# FILM
# LOCATIONS
## DUBLIN

Edited by Jez Conolly and Caroline Whelan

First Published in the UK in 2011 by
Intellect Books, The Mill, Parnall Road,
Fishponds, Bristol, BS16 3JG, UK

First Published in the USA in 2011
by Intellect Books, The University of
Chicago Press, 1427 E. 60th Street,
Chicago, IL 60637, USA

Cover photo: Samson Films / Summit
Entertainment / The Kobal Collection

Copy Editor: Michael Eckhardt

Intern Support: Krista Henderson,
Mandy Kempenich, Carly Spencer,
Hannah Evans and jacob Mertens

A Catalogue record for this book is
available from the British Library

**World Film Locations Series**
ISSN:  2045-9009
eISSN:  2045-9017

**World Film Locations Dublin**
ISBN: 978-1-84150-550-3
eISBN: 978-1-84150-592-3

Printed and bound by
Bell & Bain Limited, Glasgow

# WORLD
# FILM
# LOCATIONS
## DUBLIN

EDITORS
Jez Conolly and Caroline Whelan

SERIES EDITOR & DESIGN
Gabriel Solomons

CONTRIBUTORS
Nicola Balkind
David Owain Bates
Stephen Boyd
Jez Conolly
Scott Jordan Harris
Chiara Liberti
Paul Lynch
Colm McAuliffe
Neil Mitchell
Adam O'Brien
Díóg O'Connell
Christopher O'Neill
Clair Schwarz
Lisa Shand
Patrick Swan
Caroline Whelan

LOCATION PHOTOGRAPHY
Patrick Swan
(unless otherwise credited)

LOCATION MAPS
Joel Keightley

PUBLISHED BY
Intellect
The Mill, Parnall Road,
Fishponds, Bristol, BS16 3JG, UK
T: +44 (0) 117 9589910
F: +44 (0) 117 9589911
E: info@intellectbooks.com

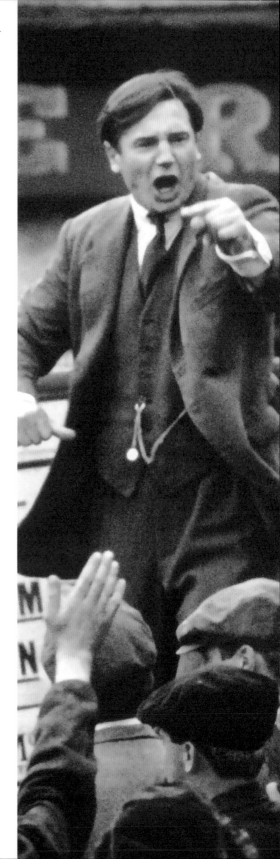

# CONTENTS

## ACKNOWLEDGEMENTS

We would like to thank Mags O'Sullivan and Naoise Barry at the Irish Film Board for helping to identify some of the locations that feature in this book. Our gratitude goes out to Chiara Liberti for liaising with the Irish Film Institute, and to Rebecca Grant and Karen Wall at the IFI for allowing access to their collection. We would also like to thank Tara Brady and the Dublin Film Critics' Circle for their enthusiasm and help in spreading the word, and Fran Reilley for help with some of the images. A huge debt of gratitude goes out to all of the contributors to the book, especially those who gave their time relatively late in the day.

JEZ CONOLLY AND CAROLINE WHELAN

# INTRODUCTION

## *World Film Locations* Dublin

*I want to give a picture of Dublin so complete that if the city suddenly disappeared from the earth it could be reconstructed out of my book.*

— James Joyce in conversation with Frank Budgen, Zurich, 1918, as told by Budgen in his book *James Joyce and the Making of Ulysses* (1934)

NO SINGLE BOOK, NOT EVEN *Ulysses*, could ever hope to capture the entirety of a city between its pages and amount to a blueprint for its restoration. What the titles in the *World Film Locations* series aim to do is present a selective snapshot of the featured cities through the medium of the movies made or set in them and allow the reader to inhabit these spaces, passing through a stimulating choice of words and pictures that inform and precipitate an imagined exploration.

The city under scrutiny in this volume may not immediately spring to mind as a widely featured cinematic location, but in fact there is a surprising wealth of films to draw upon which ably illustrate the unique qualities and character that Dublin possesses. What is also surprising is that, unlike some of the other cities to feature in this series, there seem to have been precious few previous attempts to condense a visual and textual impression of cinematic Dublin in book form.

To be clear from the outset, this book is not a completist's list of film locations in and around Dublin, nor is it an exhaustive examination of film-making in the city. It does not set out to serve as a record of every film, let alone every film scene, shot in Dublin. Neither is the book a travel guide, though it could serviceably function as one, whether the reader chooses to use it on an actual tour of the Fair City on foot or as a route map on an imaginary odyssey.

This volume collects together over forty reviews of scenes from films either shot or set in Dublin. The pieces are illustrated by images from the scenes in question, and photographs of locations, often as they are today. Together, the words and images expose the relationship between a scene's setting and its impact on the viewer. The short scene reviews are interspersed with more detailed, meditative essays that are designed to examine in greater depth some of the key aspects of Dublin as seen on-screen; the city's political and literary histories are appraised, as are its music scene, its familiar faces, its element of organised crime and its fluctuating attributes before, during and after the Celtic Tiger era.

Taken as a whole, this book constitutes a rare written instance of Dublin encapsulated in moments of film, brought together and supplemented by a pictorial toolkit designed to enable a conceptual tour of the city in its various incarnations. If Leo Bloom were a movie-goer he would probably have had a copy of the book in his jacket pocket when stepping out on the sixteenth day of June ...

*Jez Conolly and Caroline Whelan, Editors*

# DUBLIN

*City of the Imagination*

Text by
JEZ CONOLLY
AND
CAROLINE
WHELAN

**IN HIS POEM** 'Nights on Planet Earth' Campbell McGrath refers to Dublin as an 'ideal city of the imagination,' likening it to 'a movie you can neither remember entirely nor completely forget.' This neatly sums up the semi-illusory experience of finding and spending time in the cinematic Dublin. By turns what one discovers is a screen-place that is never quite what it seems and yet so much more than might be expected.

Despite, or perhaps because of this dichotomy, Dublin conforms well to the notion of the 'urban imaginary' put forward by James Donald in his book *Imagining the Modern City*. Donald puts the case that representations of the city teach us how to see and make sense of it: 'It defines the co-ordinates for our imaginative mapping of urban space.' For Donald, the role of the city as a state of mind produces a blurring of the boundaries between the real and the imagined city: 'It is true that what we experience is never the real city, 'the thing itself.''

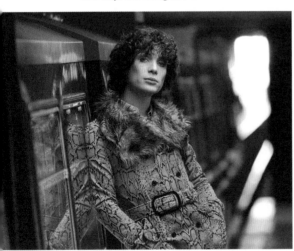

With regard to Dublin's relationship to and representation through cinema, a useful starting place can be found by looking back to the early cinema-going habits of the city's population. The history of film in Dublin dates back to the dawn of cinema itself. The city witnessed screenings of the Lumière brothers' films in April 1896 in the Star of Erin Music Hall on Dame Street (now known as the Olympia Theatre and used as a filming location one hundred years later for Mike Newell's *An Awfully Big Adventure* [1995]), and the first known moving images of Dublin were captured less than a year later. The Volta, Dublin's first purpose-built cinema was opened at 45 Mary Street in 1909 and was managed, for a few weeks at least, by none other than James Joyce. By 1922 there were 37 cinemas in business in Dublin.

This rise in popularity of the medium among Dubliners was not immediately reflected in a wave of Dublin-set film productions. The battle for national independence and the censorious nature of the Catholic authorities are in part behind this initial lack of production impetus. While it is certainly possible to compile a list of notable films shot or set in Dublin since those early days, the number of productions that one might routinely associate with the Irish capital seems, upon initial reflection, to be somewhat dwarfed by the role call of movies that can be readily attributed to many other major cities. To understand why this is the case one must first examine the wider history and culture of Irish Cinema to see how the country and the city have been depicted through both Irish and non-Irish films.

Up to the end of the 1970s the tendency was for US-backed films set in Ireland to

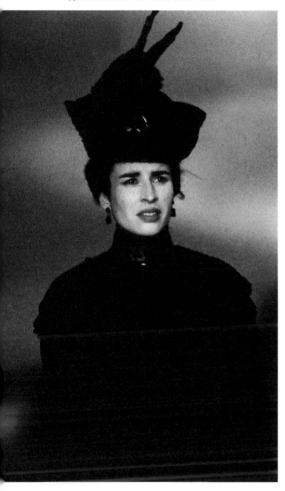

looking for a story or a location that would appeal to a wide audience.

For a country that has repeatedly featured in the world's top ten of cinema-going per capita statistics there seems to have been a comparative lack of appetite among home audiences for Irish-made films singularly intended for Irish consumption, at least until relatively recently. Film was simply not the medium through which Irish culture routinely exerted itself.

The advent of the Celtic Tiger era has changed all that. The fluctuating conditions experienced during this period have led to a succession of home-grown films, many of them figuring Dublin as the indicative face of change. To a greater or lesser degree the films have set out to examine what it is like to live through these interesting times, from the brightly-coloured hedonistic highs to the shameful, squalid lows of a society and a city effectively being recreated at great speed. These films have found a substantial indigenous audience, reflected in the setting-up of the Irish Film Institute located in Temple Bar, the re-emergence of the Irish Film Board, the establishment and success of the Jameson Dublin International Film Festival and the opening of new film venues such as the Light House Cinema at Smithfield, although this venue sadly succumbed to the economic downturn.

As a result of this growth of activity and focus on contemporary metropolitan issues as the central themes of many more Irish films, it would seem that cinema has finally secured its place at the country's cultural top table and it looks set to stay there despite the post-Celtic Tiger comedown. Film-makers have demonstrated their ability to respond to the perpetual flux of the city and in their own way are contributing to the tradition of transcribing a Dublin of the imagination. James Joyce's *Ulysses*, acting as a fictional recording of the people and the places, fixed Dublin in the imagination forever. The film scenes that feature in this book are mere flickers of memory by comparison but they constitute an approachable projection of an imagined Dublin, neither remembered entirely nor completely forgotten, that is ripe for exploration. ✢

exploit the more hackneyed pastoral and traditional preconceptions of Irish culture and society. So the view of Ireland seen by the world was typified by the likes of John Ford's *The Quiet Man* (1952) and to some extent David Lean's *Ryan's Daughter* (1970). The pull of the rural or coastal wilderness of the country meant that Dublin, with its turbulence and politics, tended not to figure in the minds of many producers

**Film-makers have demonstrated their ability to respond to the perpetual flux of the city and in their own way are contributing to the tradition of transcribing a Dublin of the imagination.**

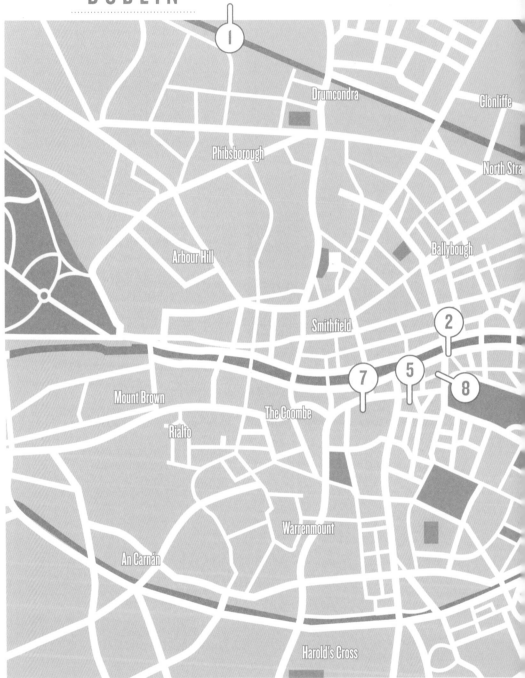

# LOCATIONS
## SCENES 1-8

# SHAKE HANDS WITH THE DEVIL (1959)

LOCATION *Glasnevin Cemetery, Finglas Road, Dublin 11*

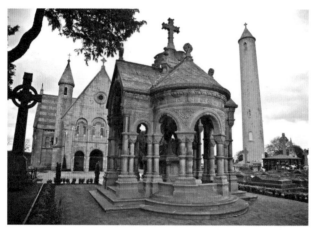

*'When I came back to Dublin I was court-martialed in my absence and sentenced to death in my absence, so I said they could shoot me in my absence.'*

– Brendan Behan, given an Irish Republican Army funeral at Glasnevin in 1964

**GLASNEVIN CEMETERY** is home to the graves of approximately 1.2 million people. Among the names on the headstones one can find those of Parnell, O'Connell, Collins, de Valera and others synonymous with Irish political history and the Republican struggle. Michael Anderson's *Shake Hands with the Devil* opens with a lingering crane shot showing a multitude of shadows being cast across the consecrated ground by the many monuments and memorials. An ominous voice-over dates and sets the scene: 'Dublin, 1921 - a city at war.' We see a graveside being tended by Kerry O'Shea (Don Murray), an Irish-American medical student now resident in Dublin since returning to bury his mother next to his father, killed in the 1916 Easter Uprising. A funeral procession that has passed behind him is suddenly stopped in its tracks by a unit of the Black and Tans. The coffin falls to the ground as the mourners flee, breaking open to reveal a cache of firearms inside. O'Shea covers for one of the escaping mourners under questioning, a moment that sparks his own involvement in the movement. In a film that constitutes an oversimplified whistle-stop tour of Irish Republican history, this unsubtle yet potent sequence illustrates the extent of Dubliners' siege mentality under British military pressure. **⊷Jez Conolly**

(Photos © Patrick Swan)

Directed by Michael Anderson
Scene description: The Black and Tans discover firearms concealed in a coffin
Timecode for scene: 0:02:07 – 0:03:52

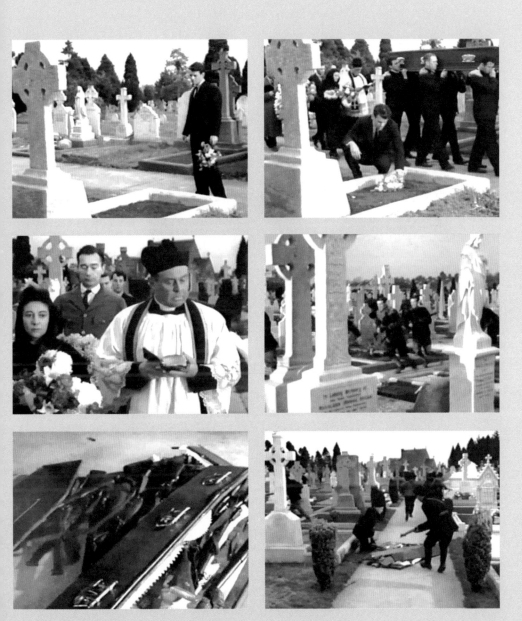

# GIRL WITH GREEN EYES (1964)

*O'Connell Bridge, Dublin*

**THIS ADAPTATION OF** the Edna O'Brien novel *The Lonely Girl* depicts two young women enjoying urban independence following their restrictive rural upbringing. Quiet country girl Kate Brady (Rita Tushingham) and her fun-loving friend Baba Brennan (Lynn Redgrave) seek the fun and freedom that the big city has to offer. Kate falls for middle-aged writer Eugene Gaillard (Peter Finch) and they embark on a relationship, despite the disapproval of her sternly Catholic family and his estranged wife's interfering friends. There is a moment early in *Girl With Green Eyes* when Kate and Baba are strolling across O'Connell Bridge. Their friend Bertie (Pat Laffan), driving a banged-up old van, asks them to join him on a trip to do some business in the Dublin Mountains. He holds up traffic while calling them over ('For Pete's sake, get a move-on: this yoke's not taxed!') and they decide to go with Bertie, Baba taking the passenger seat and Kate huddling into the back of the vehicle. The sequence may be brief but is significant since it establishes the busy urban lifestyle: there are multiple people moving along the footpaths, the roads are bustling with traffic and there is the constant opportunity for an impulsive sense of adventure. This is in stark contrast to the scenes which take place in Kate's rural family home: isolated within a community who have condemned her love affair with a married man, she finds herself emotionally and literally alone in the serene yet desolate surroundings of the countryside.
➻ *Christopher O'Neill*

(Photo © Hans-Peter Bock)

Directed by Desmond Davis
Scene description: Bertie invites Kate and Baba for a drive to the Dublin Mountains
Timecode for scene: 0:08:09 – 0:08:56

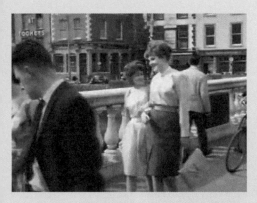
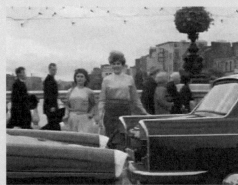

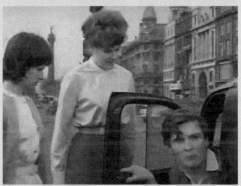

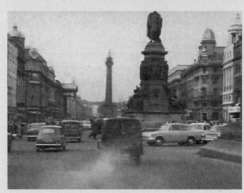

# ULYSSES (1967)

LOCATION *From Sandymount Strand, Sandymount, Dublin to Prospect Cemetery, Glasnevin, Dublin*

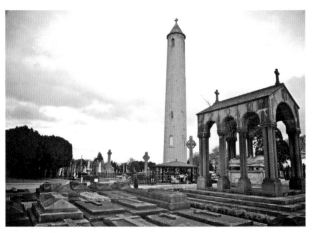

**ULYSSES IS A NOVEL** rooted, perhaps more so than any other, in a sense of place. This aspect, although perhaps one of the less prominent reasons why the book has long worn the tag 'unfilmable,' would make any attempt to capture its essence difficult. The decision by maverick American film-maker Joseph Strick to base his adaptation of Joyce's novel in 1960s Dublin rather than its original setting of 1904 ensures the *mise-en-scène* does not take anything away from the film text, and in fact serves to highlight the unlimited contemporaneity of Joyce. If anything, this juxtaposition of past and present affords the film a unique timelessness. Joyce's attempts to plan out the winding topography of Dublin city is perfectly depicted during this carriage ride from the South to the North of the city, stopping beside the Grand Canal where we catch a glimpse of the gasworks mentioned in the novel, and offering us a unique depiction of industrial Dublin in the 1960s. Film critic Bosley Crowther commented upon the city's modernity during this passage: 'the streets are full of automobiles. The quays along the river are crowded with modern ships.' As the carriage moves northwards towards Glasnevin, we witness waterways enlivened with the sights and sounds of birds as we see flocks of seagulls over Sandymount Strand and over the Liffey.

↪ *Colm McAuliffe*

(Photos © Patrick Swan)

*Directed by Joseph Strick*
*Scene description: Bloom travels in a funeral carriage through Dublin city*
*Timecode for scene: 0:21:58 – 0:25:44*

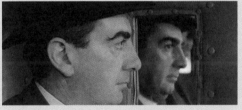
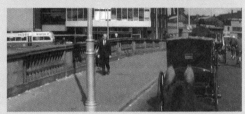

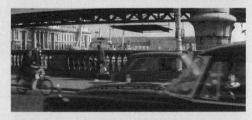
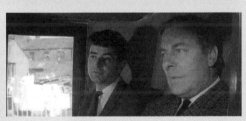
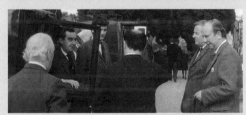

Images © 1967 Arrow

# THE ROCKY ROAD TO DUBLIN (1968)

LOCATION *Peamount Hospital, Newcastle, Co. Dublin*

**THE YOUNG PRIEST**, Father Michael Cleary, snaps his fingers, swings his knees, taps his feet and sings a rendition of *Chattanooga Shoe Shine Boy* for a roomful of bemused sick women in a Dublin hospital. This bizarre moment cuts to the heart of an Ireland that Peter Lennon wanted to capture in his excoriating 1968 documentary. The charismatic Cleary had been sent out by the Catholic hierarchy to show how down to earth the priesthood had become. Instead, Cleary's behaviour helped show the smothering control of the church and the extent of the public's servility to it. The film shows the Irish Catholic church policing the populace like a secret service. They lecture you about sex on your wedding day, sing songs to you while you are dying and patronize you by the graveside. And they will make sure to stifle any cultural debate. Lennon set out to explore the theme: 'What do you do with your revolution once you've got it?' And he proceeded to show Ireland in the 1960s as a cultural backwater – in the clasp of censorship, brainwashed by the church and populated by what Sean O'Faolain called 'urbanised peasants'. The documentary was effectively banned in Ireland for 30 years. Coutard's fleet-footed, fly-on-the-wall style captured an Ireland unaware of itself and damning itself out of its own mouth. Decades later, the all-singing, all-dancing priest was found to have been engaging in sexual relations with his 17-year-old housekeeper while at the time of filming, making the portrait complete. **➙ Paul Lynch**

(Photo © Michael Fewer)

*Directed by Peter Lennon*
*Scene description: Priest sings song to sick patients in hospital*
*Timecode for scene: 0:46:55 – 0:48:13*

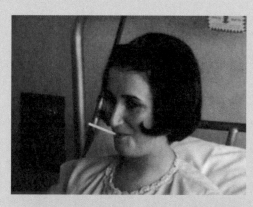 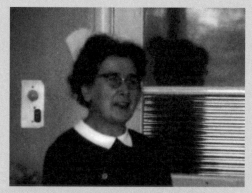

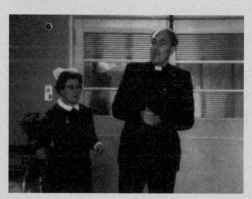 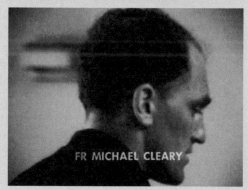

Images © 1968 Soda Pictures

# EDUCATING RITA (1983)

LOCATION *The Stag's Head Pub, 1 Dame Court, Dublin 2*

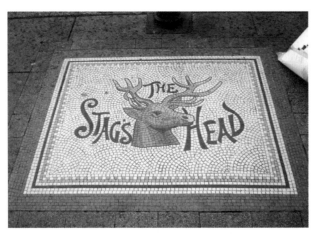

**IN *EDUCATING RITA***, Dublin stands in for Liverpool throughout. Rita (Julie Walters) is a hairdresser who takes an Open University course, and the alcoholic, world-weary Dr. Frank Bryant (Michael Caine) is her lecturer. Despite initial reluctance, he warms to the engaging and un-cynical Rita to the extent that he asks her to a dinner party he is hosting. In an extended scene the initially excited Rita makes it as far as his front steps only to be intimidated by the prospect of entering into an unfamiliar and daunting environment. She finds herself back at her local pub, where her husband, parents, sister and assorted friends are singing along to the jukebox. Her husband, who disapproves of her studies, welcomes her back into the fold and she takes a seat at the table. Later she tries to get Frank to understand her fears about not fitting in his world. In a beautifully realized combination of flashback and voice-over she explains to him the painful undercurrents of what seems from the outside to be a happy sing-a-long. Without pretension she deconstructs for him the situation more confidently than she could have done before they met, summing up her frustrations in her unhappy mother's words: 'There must be better songs to sing than this'. The ornate but unpretentious interior of The Stag's Head in Dublin perfectly frames the tensions and frustrations she articulates. She sits lonely in a crowd of people she no longer feels a sense of belonging with, and yet is terrified of leaving.
**⤍David Bates**

(Photos © Patrick Swan)

*Directed by Lewis Gilbert*
**Scene description: Rita caught between two worlds**
**Timecode for scene: 0:43:28 – 0:49:10**

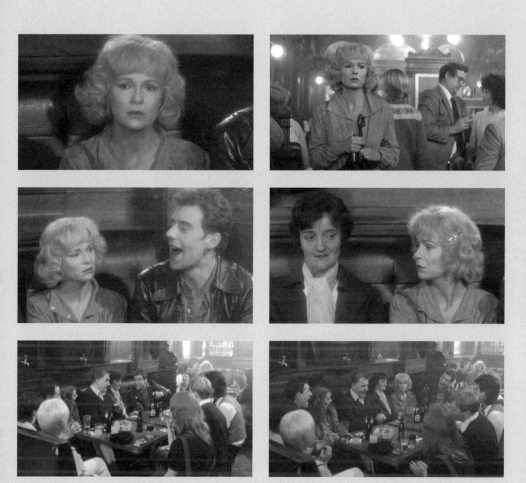

# PIGS (1984)

LOCATION *Sir John Rogerson's Quay, Dublin 2*

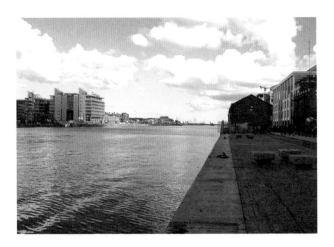

**JIMMY (JIMMY BRENNAN)** breaks into a derelict Georgian tenement and sets up residence before quickly being joined by other social outcasts: conman George (George Shane), mentally-unstable Tom (Maurice O'Donoghue), drug dealer Ronnie (Liam Halligan), Jamaican pimp Orwell (Kwesi Kay) and his girlfriend/prostitute Mary (Joan Harpur). But tension arises within the group as these extreme personalities clash and the pressures of the outside world mount. From its nocturnal opening shots of dilapidated buildings, burning cars and boarded-up houses, *Pigs* paints Dublin as a claustrophobic ambushment for characters who find themselves marginalised by society. Former seaman Jimmy yearns for escape but finds himself compounded by his situation. He visits old friend Doc (Pat Daly), whose current cargo ship is moored in Dublin, in the naïve hope of finding work, but all he can offer is a couple of beers and a few packets of duty-free cigarettes. In one of the few moments in *Pigs* where a wide-open exterior location is used, Jimmy and Doc stand on deck overlooking the Liffey while, in the distance, the North Bank of the river can be seen. It is early morning, the sky is dark blue and the ship is ready to depart. Despairingly, Jimmy sings a bawdy tune – which he no doubt learnt on one of his past voyages – before bidding farewell. The sequence ends with a panning shot of Jimmy standing ashore and watching the vessel slowly leave his sight as it sails away. Jimmy's hope of fleeing Dublin is thwarted and he returns to his makeshift home at the squat.
**⤙Christopher O'Neill**

(Photo © John Gibson)

*Directed by Cathal Black*
Scene description: *Jimmy sees off Doc as he sets sail for Liverpool*
Timecode for scene: *0:36:14 – 0:37:55*

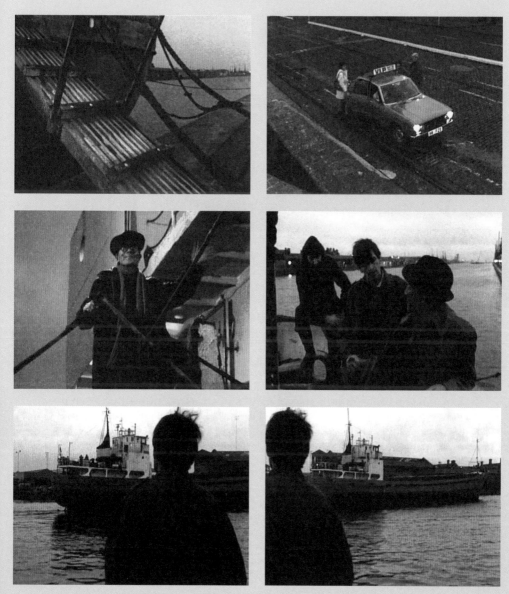

Images © 1984 Funded by the Irish Film Board and RTE

# THE DEAD (1987)

LOCATION *From Dublin Castle to the city quays*

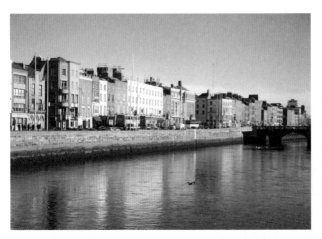

**THE DEAD IS AN ADAPTATION** of James Joyce's short story of the same name and the last film directed by John Huston. Set on 6 January 1904, the Feast of the Epiphany, the story unfolds at a dinner party hosted by the Morkan sisters and their niece Mary Jane (Ingrid Craigie), and attended by their nephew Gabriel Conroy (Donal McCann) and his wife Gretta (Anjelica Huston). Just before the last few remaining guests depart and as she descends the stairs, Gretta is moved to sentiment by the distant tune of 'The Lass of Aughrim'. Later she recounts a story to her husband of a lost love, a story Nora Barnacle once told James Joyce, the telling of which has a profound effect on Gabriel. This scene shows the cab journey taken by Gretta and Gabriel back to their hotel. Beautifully shot in snow covered streets that appear lit only by gas lamps and the blue hue of the night sky, the cab journeys away from Dublin Castle, along the quays and across an imagined O'Connell Bridge. Anticipating the tragic story that Gretta later recounts to Gabriel while in their hotel bedroom, it is as if they are being driven by Death himself. The contrast of the white snow with the silhouetted cab driver suggests the simultaneous birth within Gabriel as he learns of the death of his wife's first love and becomes aware that he has never experienced such intense love. This awakening of knowledge corresponds to the death of an opportunity he will never have. **✛Dióg O'Connell**

(Photos © Patrick Swan)

*Directed by John Huston*
*Scene description: A carriage drives along Dublin city's quays as snow falls, 6 January 1904*
*Timecode for scene: 1:01:52 – 1:02:14*

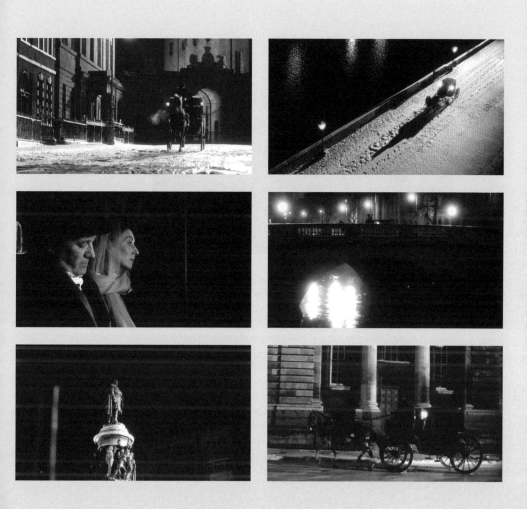

# THE COURIER (1988)

*Foster Place, Dublin 2*

**WHEN HIS OLD FRIEND** Danny (Andrew Connolly) is murdered, motorcycle courier Mark (Padraig O'Loinsigh) plots an elaborate scheme to bring those responsible to justice: crime kingpin Val (Gabriel Byrne), who ordered the killing, and Detective McGuigan (Ian Bannen), who exploited Danny as an informant. The pursuit for revenge consumes Mark, putting himself and those closest to him in danger. Uniformly panned by the Irish media upon its original release, *The Courier* is a thriller that, despite misjudged handling of the film's melodramatic 'romance' scenes, possesses a convincingly unflinching depiction of criminal brutality. Pre-Celtic Tiger Dublin proves to be an effective backdrop for the unfolding drama, which ranges from anonymous contemporary tower blocks to the nineteenth century elegance of Foster Place, a leafy cul-de-sac which houses the former armoury of the Bank of Ireland. The latter location is used when Val's henchmen attempt to abduct Mark's girlfriend Colette (Cait O'Riordan) who, unbeknownst to them, is being used by McGuigan to ambush them. The sequence begins in disarming stillness with a tracking shot of Colette, hands in pockets, slowly walking towards her place of employment. As the shot progresses various armed policemen can be seen, backed by a mournful saxophone solo soundtrack. When a vehicle pulls up and a henchman (Patrick Bergin) attempts to grab Colette, the intimacy of the location is disrupted. Suddenly the area is surrounded by hordes of Gardaí officers while in the background city life can be seen to carry on undisturbed, represented by the continuous traffic on Dame Street. ➡ *Christopher O'Neill*

*Directed by Frank Deasy and Joe Lee*
*Scene description: McGuigan uses Colette to lure out the criminals*
*Timecode for scene: 1:13:04 – 1:15:10*

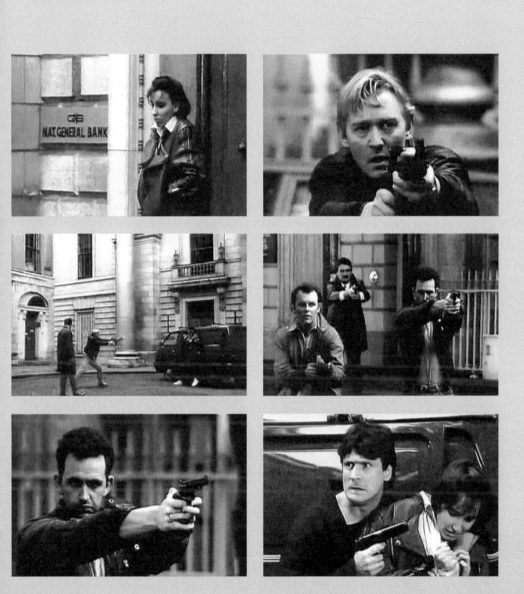

# THE GRAFT ON GRAFTON

Text by
NICOLA
BALKIND

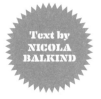

*Dublin's Music Scene On-screen*

**DUBLIN'S MUSIC SCENE** is out in the open. Take a stroll down Grafton Street and you'll find one of the largest collections of musical street performers in Europe, if not the World. Two films that take on Dublin's music scene – past and present – are *The Commitments* (Parker, 1991) and *Once* (Carney, 2006). From soul to acoustic rock, both bring Dublin's music scene out into the open, extending the power and message of their music to the masses. From the meditative to the upbeat, these two films embody much of what is to be learned about Dublin's music scene.

A major point of similarity between the films is the presence of Glen Hansard – songwriter, singer-guitarist of Irish group The Frames, and one half of folk rock duo The Swell Season. Hansard got his start busking on Dublin's streets, having quit school at 13 to do so. As well as co-starring as guitarist Outspan Foster in *The Commitments*, he plays the unnamed protagonist (credited as

'Guy') in *Once*. Hansard also wrote the film's soundtrack song 'Falling Slowly', for which he won the Academy Award for Achievement in Music Written for a Motion Picture (Original Song) in 2008.

*Once* wastes no time in delving into its personal story of musical experience. Opening on Guy busking on Grafton Street and getting into a scuffle with a homeless man, the next time we see him he's back on the main street playing a song of his own. When 'Girl' (a Czech immigrant played by Markéta Irglová) approaches him with ten cents and the offer of a Big Issue magazine, he explains to her that he plays well-known songs during the day because that's what people want to hear. There's no money in busking, and still less when he plays his own music. It is clear throughout the film that Dublin's true music scene lies out of doors, as he plans to depart for London to strike it big with his own demo and dreams of a contract.

*The Commitments*' Jimmy Rabbitte (Robert Arkins) also dreams of a recording contract. Defining himself as the cultural catalyst for music, pushing Soul as the next big genre, he forms a band called The Commitments, whom he manages. The members have their squabbles, but Jimmy is seldom there to solve them. Instead, he is working hard to keep their attention on the music and, most importantly, bring in the money. This representation of the Dublin music scene is more rough-and-ready than Carney's deeply personal approach. As well as being set in the 1970s, *The Commitments* portrays the community as music-loving and spotlight keen, but generally lacking in Jimmy's vision of talent and style. While music is a personal venture that can turn into greater prospects in *Once*, *The Commitments* focuses primarily

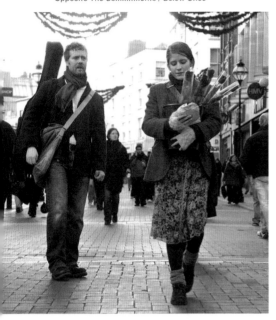

aspects of music are at the forefront, the alliance of music is beautifully stated and quietly understood.

*The Commitments* similarly spends much of its screen time documenting the band's first rehearsals, fumbling over lines of 'Mustang Sally' repeatedly until the members finally begin to find a rhythm. Both films use key songs – namely 'Mustang Sally' and 'Falling Slowly' – throughout to communicate the state of relationships between players and forecast upcoming hiccups and triumphs. Jimmy's goal is to form 'the hardest working band in Dublin.' Though he seems to have succeeded, the band's priorities lie not in becoming one, but pursuing their own path to fame. What is more important for *The Commitments* is exposure, and the film's master stroke is the locations into which it brings us. Rehearsing in a musty storeroom – the only place they can find room enough for all ten members and their equipment – The Commitments are at home wherever they are welcome. Their initial gigs take place at a local church and, despite disastrous results, the community's encouragement pushes them towards success. Though at surface level it seems provincial, the camaraderie here is testament to location; a friendly, family-oriented, Catholic-leaning community that's at the centre of a big city but keeps its traditional values. While their music is American in genre and style, its people's personality keep the vibe distinctly Dublin.

And what is more Dublin than Grafton Street? The busy strip in Dublin's city centre is Guy's home-from-home in *Once*. It's where he spends his non-working hours, and regardless of the hassle and poor tips he receives from the locals, his passion is engendered in this shopping street. Guy performs in front of HMV – a symbol of the music industry – as though waiting for it to absorb him. Though *The Commitments* doesn't have this same commitment to the streets, it is cited as an alternative for Dublin musicians, as two of its members make a beeline for Grafton as soon as the band splits. The graft is the same, however, and it's with great bravery and a community spirit that the graft on Grafton becomes essential to Dublin's music scene on-screen. ✠

on the struggles to become rich and famous, where image is valued over musical meaning and togetherness.

Despite their difference in approaches, music is foregrounded in both films, with long sequences devoted to full songs. Key scenes in *Once* include Guy teaching Girl his new song as they jam together in a music shop. The connection forged as he guides her on piano while strumming his guitar echoes throughout the film; a testament to the power of music in forming a bond. Lingering hand-held cameras take in the scene from all sides, lending an intimacy that allows us to enjoy and share in the spontaneity of the moment. Throughout the story she's too shy to reciprocate – another personal flourish that inspires our appreciation for Guy's capacity to share. When she confides in him a song she's worked on for years, sharing a moment in a hidden room in the recording studio, we see it ignite Guy's passion even farther. Though the personal

**The connection forged as he guides her on piano while strumming his guitar echoes throughout the film; a testament to the power of music in forming a bond.**

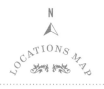

Drumcondra

Glonliffe

Phibsborough

North S

Arbour Hill

Ballybough

11

14

Smithfield

16

9

12

13

Mount Brown

The Coombe

Rialto

Warrenmount

An Carnán

Harold's Cross

15

# LOCATIONS
## SCENES 9-16

# MY LEFT FOOT (1989)

*Mulligan's (AKA John Mulligan's), 8 Poolbeg Street, Dublin 2*

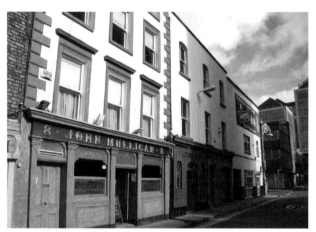

**DANIEL DAY-LEWIS** dominates *My Left Foot* with his portrayal of Christy Brown, who overcame both crippling poverty and crippling cerebral palsy to become an acclaimed painter and author using the one part of his body he could control – that eponymous left foot. One of the film's most memorable scenes, however, occurs before he has taken over the role, and Christy is just a newborn. Learning of his baby's disabilities, Paddy Brown (Ray McAnally) retreats to his local pub, in a scene shot at Mulligan's on Dublin's Poolbeg Street. He demands drink. A man asks if he'll put Christy in a home, and he answers that he'll put him in a coffin first. Another man tauntingly asks if now he'll abandon 'breeding'. In response, Brown headbutts him. 'Paddy – there was no need for that,' says the publican. 'A shut mouth catches no flies,' he answers, before stalking out. It is a powerful scene – funny, shocking and unsettling – but one made more powerful because it foreshadows another. Years later, when Christy (still not yet played by Day-Lewis), shows he can write, and draw, and think, his father returns to the pub with the crippled boy on his shoulder. The first Mulligan's scene saw him stride out, ashamed of his offspring. The second sees him stride in and declare, 'This is Christy Brown, my son – genius!' It is a triumphant high point, but we can only fully see it as such because of the contrast with that earlier, abrupt headbutt.
**↝Scott Jordan Harris**

(Photos © Patrick Swan)

*Directed by Jim Sheridan*
*Scene description: 'A Shut Mouth Catches No Flies'*
*Timecode for scene: 0:07:16 – 0:08:23*

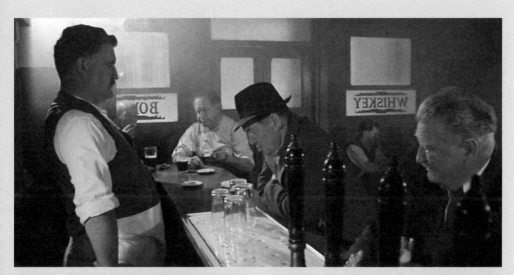

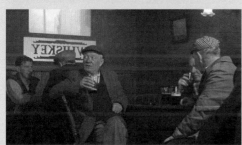

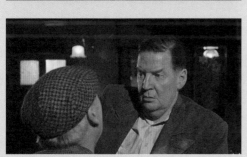

# THE COMMITMENTS (1991)

*Sherriff Street, Dublin*

**THE COMMITMENTS** opens with stark white-on-black credits overlaid with lively Soul beats. At odds with the Irish names but lyrically effective, the juxtaposition of its first images are discordant yet perfectly in tune. The image shifts to Dublin's Sunday morning marketplace, a busy miscellany of stalls, farm animals, and music. A boy sings a cappella on a corner, nostrils flaring; the sound of a fiddle drifts above the crowd without piercing the atmosphere, and the atonal bartering shouts of salesmen are all-encompassing. Though music surrounds aspiring band manager Jimmy Rabbitte (Robert Arkins), his attempts to sell his T-shirts and tapes to market stall holders are fruitless. Despite Jimmy's stylish flair, a punk, pony-tailed cassette salesman turns him away. These are the days before Soul was in style. It is on trains among the teenagers where Jimmy's distinctive taste drives his best business. Nevertheless, he tries. What's implicit at Sheriff Street Market is that the same style of local, pre-'car boot' trade is taking place across Dublin in its numerous locales. Guitarists sing and strum on acoustic guitars - not for pennies, as they do now on Grafton Street – for the love of music, the atmosphere and, most important, an audience. Through Jimmy's eyes we see this elaborate musical culture take form, but it's a mess of modern and traditional, without the factor of cool that Jimmy fancies he brings. Without knowing his style, the voiceover lends him authority, inviting us into an Irish subculture that emerged through the man himself in 1970s Dublin.
➥ **Nicola Balkind**

(Photos © Patrick Swan)

*Directed by Alan Parker*
*Scene description: Opening scene at a Dublin market, Jimmy selling cassettes & t-shirts*
*Timecode for scene: 0:01:47 - 0:04:00*

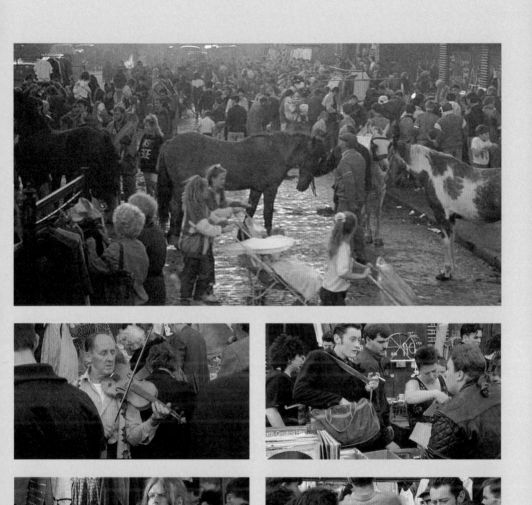

Images © 1991 Beacon Communications/20th Century Fox

# THE SNAPPER (1993)

LOCATION *Patrick Conway's pub, 70 Parnell Street, Dublin 1*

**THE SECOND INSTALMENT** of Roddy Doyle's Barrytown trilogy is an amusing and uplifting slice of life set in a close-knit community in North Dublin. The film examines the reactions of the community when Sharon Curley (Tina Kellegher) finds herself pregnant after an older man (the father of one of her friends) takes advantage of her when she is drunk. More specifically the film focuses on Sharon's father Dessie's (Colm Meaney) reactions to the pregnancy. We follow him through a process of change, from his initial reactions of anger and embarrassment to gradual interest in the 'mechanics' of pregnancy and childbirth. He is trying on the role of a modern father. The uplifting moment comes when we see Dessie celebrating the birth of his grandchild with a pint of Guinness in Patrick Conway's pub on Parnell Street opposite the Rotunda Maternity Hospital. Conway's has become the traditional place where many a new father wets the baby's head. Intercut with shots of Sharon feeding her newborn, we see Dessie as he appraises his pint with a look of excitement and a feeling of satisfaction, rather like Sharon's baby looking at his mother's breast in readiness to be fed. Dessie downs the pint, burping contentedly afterwards, just as Sharon's baby is being winded. The celebratory drink shows us that Dessie is now happy about the situation, but the comparison of the sinking of the pint with the baby suckling suggests that despite this acceptance, Dessie still lacks the emotional maturity of the strong women in his family. **•▶Caroline Whelan**

(Photos © Patrick Swan)

*Directed by Stephen Frears*
**Scene description: Dessie downs a pint**
**Timecode for scene: 01:25:39 – 01:27:30**

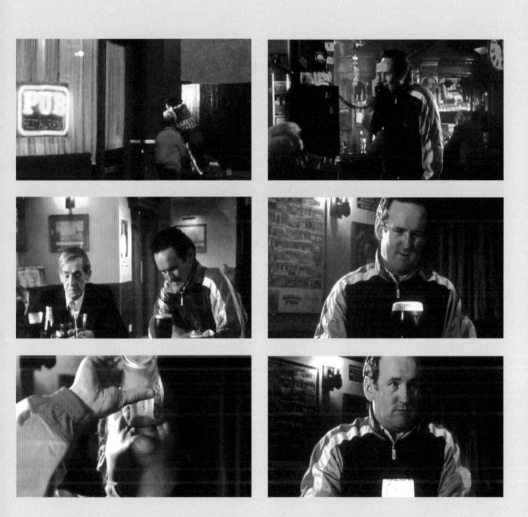

Images © 1993 BBC

# A MAN OF NO IMPORTANCE (1994)

LOCATION *The Stag's Head, 1 Dame Court, Dublin 2*

**A MAN OF NO IMPORTANCE** tells the story of Alfie Byrne (Albert Finney) who conceals his homosexuality in the sexually conservative Ireland of the 1960s. A bus conductor in Dublin's inner city, he is a devoted 'Wildean' who proposes to stage a play involving the local people on his bus route and in his community. In *A Man of No Importance*, the narrative moves forward at two levels: at the level of exterior struggle, Alfie attempts to stage a production of Oscar Wilde's play *Salomé* in a society that is closed, inward looking and censorious. This is matched by the interior struggle of his awakening sexuality. In the scene illustrated, Alfie bravely goes out publically dressed in his Wildean garb. At this moment Alfie has reached the point of sexual awakening. He tentatively enters the gay bar and innocently asks for a cuddle. With this brave move comes the trauma of rejection and assault. Far from presenting a sentimental, nostalgic picture of 'coming out' Alfie experiences rejection in a most aggressive way. In a direct challenge to narrative expectation, Alfie's attackers come from within the community he is seeking acceptance and approval from. The complicated and complex multi-layered narrative (that allows the interior and exterior struggles to weave and coil) gives rise to a storyworld addressing both the universal and the local. When Alfie is found beaten and bruised, he encounters the obvious discriminatory comments, but the people who matter, friends Lily, Robbie and Adele, acknowledge and endorse who he is. **Díóg O'Connell**

(Photo © Patrick Swan)

*Directed by Suri Krishnamma*
**Scene description: Coming out**
**Timecode for scene: 1:11:20 – 1:12:34**

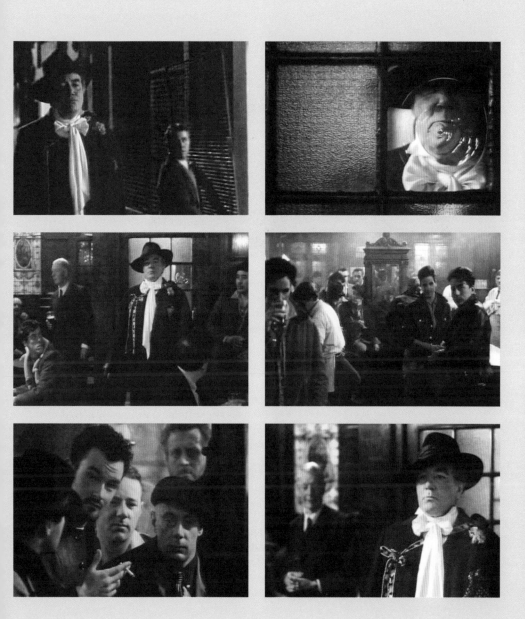

# CIRCLE OF FRIENDS (1995)

LOCATION *Trinity College Museum, College Green, Dublin 14*

**TRINITY COLLEGE**, both a world-class seat of learning and one of Dublin's most popular tourist attractions, has featured as a setting for numerous literary works. The books of J.P. Donleavy, for example, himself an alumnus of the college, tell the stories of characters who attend Trinity, including Sebastian Dangerfield in *The Ginger Man* and the eponymous protagonist of *The Beastly Beatitudes of Balthazar B*. Aspects of the college's eighteenth and nineteenth century architecture have also appealed to film-makers and can be seen in the likes of *Educating Rita* (Gilbert, 1983) and *Quackser Fortune Has a Cousin in the Bronx* (Hussein, 1970). Pat O'Connor's screen adaptation of the Maeve Binchy novel *Circle Of Friends* uses the sumptuously decorative interior of the College Museum, built between 1853 and 1857 and now housing the Geology Department, as the location for a key early scene. Bernadette (Minnie Driver), Eve (Geraldine O'Rawe) and Nan (Saffron Burrows), three childhood friends from the small town of Knockglen, are reunited in the grand hallway of the building on the first day of term. Soon after, Bernadette, the shrinking violet of the group, catches the eye of college rugby idol Jack Foley (Chris O'Donnell) as he descends the magnificent Byzantine-inspired staircase. Bernadette is smitten and dumbstruck in equal measure. As first meetings go there is little exchanged beyond an overture of lingering glances, but the richly patterned grandeur of the setting provides a suitably complex and beautiful starting point for the romance that follows. **➻ Jez Conolly**

(Photo © Bob Embleton)

*Directed by Pat O'Connor*
*Scene description: Bernadette, Eve and Nan meet at Trinity*
*Timecode for scene: 0:07:00 – 0:09:00*

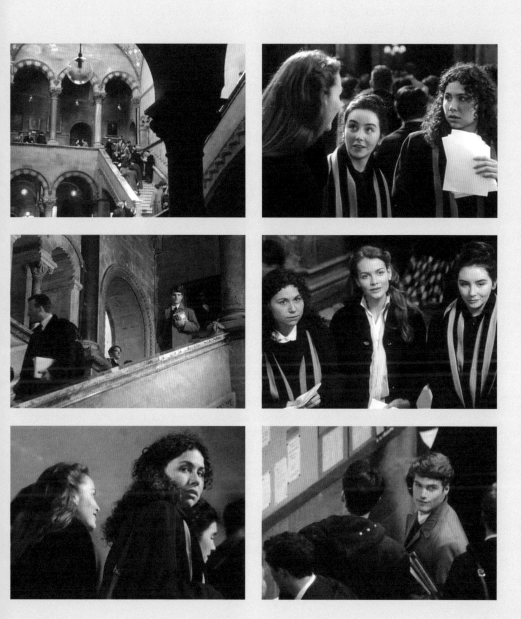

# MICHAEL COLLINS (1996)

LOCATION

*A lavish set construction, depicting a side street off O'Connell Street, and the looming GPO (still bearing the scars of the Easter Rising), Custom House Quay, Dublin 1*

**MICHAEL COLLINS** is not a film that tells its history 'bottom up'. In it, Dublin is more of a war zone, or a constellation of competing headquarters, than a bustling city. In one beautifully judged scene early on, however, we are given a brief glimpse of how the bloody struggle for independence cast its dark shadow across Dublin; even an innocuous amble on a sunny day becomes contaminated by hints of threat and unease. As the scene begins, we may or may not realise that it is Harry (Aidan Quinn) (Michael's best friend) and Kitty (Julia Roberts) (whom both the men love) walking merrily up the busy street. An elderly man is being searched by British soldiers, but Harry and Kitty walk by, determined not to let anything ruin their romantic outing. They turn the corner and nearly escape into their own blissful daydream, until Collins (Liam Neeson) appears on the scene, and chases after them with an eagerness that borders on inappropriateness. As he catches up with them, a sharp cut shifts our view 180 degrees, and reveals the huge GPO building looming behind Collins – and his intrusion takes on a darker tone. The GPO was the site of the Irish surrender in the 1916 Easter Rising, and it retained its war scars in the following years, standing as an inescapable reminder of the city's, and Ireland's, subjugation. In this scene, it almost seems to shadow the lovers, and (just as Collins does) refuses to let them forget the fateful seriousness of their situation. ⟿*Adam O'Brien*

(Photo © Stephen Sweeney)

*Directed by Neil Jordan*
**Scene description: On a lively Dublin street, 'Mick' Collins clumsily interrupts a romantic stroll**
**Timecode for scene: 0:21:20 – 0:22:09**

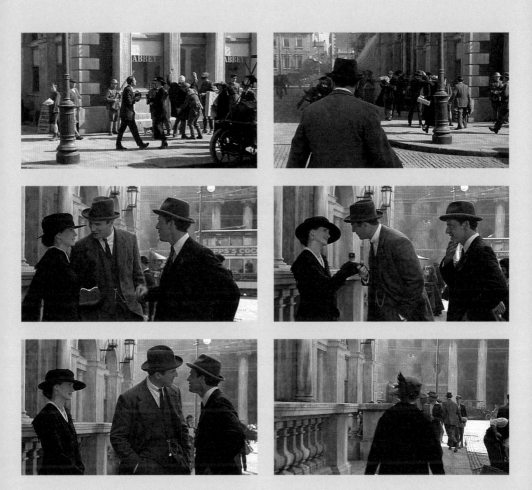

# THE LAST OF THE HIGH KINGS (1996)

LOCATION *The inside of a Dublin taxi on the road from central Dublin to Howth*

**THERE ARE MORE TAXIS** in Dublin than there are in New York City, so the taxi drivers of Dublin would have you believe. True or not, it is an example of the cabbie tendency to, shall we say, expand on the facts for the sake of a good story. Name-dropping famous passengers would seem to be another shared pastime. Stephen Rea captures this quality during a couple of show-stealing vignette scenes in David Keating's *The Last of the High Kings*. In the first of these he is the loquacious cab driver transporting the newly-arrived Erin (Christina Ricci) visiting from Milwaukee for the summer to stay with shy local teen Frankie Griffin (Jared Leto) and his family. As the car purrs around the bend of the bay Rea channels the city's literary greats in displaying his Dubliner pedigree: 'Born, bred and buttered, as yer man said.' And of course he's had all the big names in the back before now. Brendan Behan himself, and (far less believably even though the story is set in 1977) James Joyce, who according to Rea was 'very Jesuitical' and 'never had a red cent on him'. Naturally he fancies himself as a bit of a writer and tries to ply his passengers with his manuscript when, fortunately for them, the cab arrives at its destination. The taxi is a little bubble of blarney containing within it just enough of the rarified Dublin air to sustain the driver's tall stories.

**⟿ Jez Conolly**

(Photo © William Murphy)

*Directed by David Keating*
**Scene description: Born, bred and buttered as yer man said**
**Timecode for scene: 0:35:14 – 0:37:14**

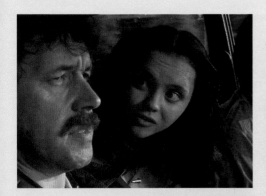 

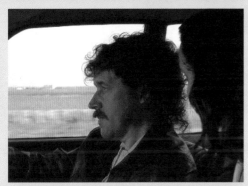 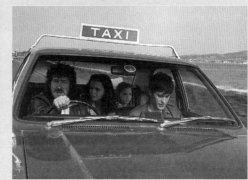

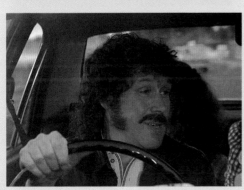 

# SNAKES AND LADDERS (1996)

LOCATION *Central Bank Dame Street, Crown Alley, Temple Bar Square*

**SNAKES AND LADDERS** is a comedy set in Dublin during the early days of the Celtic Tiger and plays out largely in the pulsating heart of the city. In one scene Jean (Pom Boyd), a young busker and her longtime friend Kate (Gina Moxley) are shown rehearsing at the Central Bank and Financial Services Authority of Ireland in Dame Street, commonly considered one of the most recognizable meeting points in Dublin. Behind them stands 'Crann an Óir' (the Golden Tree), a shining golden sculpture by Eamon O'Doherty symbolizing the new Irish growth and distribution of wealth in the Nineties. Its visual antithesis to Jean and Kate's performance could be read as the representation of a city willing to show itself with as lively, modern and competitive a face as any other European city. The two girls conclude their performance and head to Temple Bar Square, framed here as a construction site. Temple Bar, featuring predominantly in the film, and typically at night, is depicted in this particular scene under the bright sun of a summer's day. With the multi-coloured graffiti illuminated by rays of light as their backdrop, Jean and Kate start arguing and what the audience perceives here is the crumbling of a friendship, punctuated by an indolence to restrictions and a search for freedom. This scene not only conveys a significant turning point in the film, it also constitutes an homage to the profound transformation of the urban landscape of Dublin during the Nineties. ➻*Chiara Liberti*

(Photo © Tom Courtney)

*Directed by Trish McAdam*
Scene description: Jean and Kate rehearse in Temple Bar
Timecode for scene: 0:48:26 – 0:49:45

Images © 1996 Filmax International

# MOUNT RUSHMORE ON THE LIFFEY

## *Four Faces of Dublin*

Text by
JEZ CONOLLY
AND
CAROLINE
WHELAN

**THE LAST 25 YEARS** has witnessed the cultural demolition of an old Dublin, a Dublin fronting an outmoded, whimsical, postcolonial vision of Ireland and Irishness as a whole. Towers of glass and steel have emerged and glittered amid the city's Georgian firmament. Dereliction has been pushed aside by 'the Boom.' However, as with other great cities, the planners and license-holders have paid lip service to preservation and put the place's identity at risk in the process.

How then, at a time when the face of Dublin has been homogenized by architectural and cultural cosmetic surgery, has the city clung on to its identity? This quarter century, while witnessing the city's character-mediating makeover, has also seen the reemergence of the Irish Film Board / Bord Scannán na hÉireann as a champion of metropolitan authenticity through the Dublin-set movie projects it has helped develop. After an initial six-year lifespan between 1981 and 1987, when the films it backed failed to make much

of an impression at the box office, the IFB rose again in 1993 with the vigorous backing of then-Minister of Arts, Culture and the Gaeltacht Michael D. Higgins, in time to ride on the back of the Tiger, play its part in the process of pulling in overseas film productions through tax incentives, and effect the making of a slew of homegrown films that got at the heart of the city more actively and accurately than any other previous period of Irish film-making.

In the process a cast of familiar faces has emerged to populate this new on-screen Dublin and in so doing have, in one form or another, come to embody the place. Among them the career paths of four exceptional and ubiquitous actors, all of them sons of the city, have intertwined and rendered them iconic, almost as much a part of the onlooker's perception of Dublin as any architectural landmark.

Brendan Gleeson was born in 1955 and is a graduate of University College Dublin where he studied English and Gaelic. He was an avid reader as a child, especially of the work of Samuel Beckett, and he performed in his school play production of *Waiting for Godot*. Gleeson gained valuable acting experience at the Royal Academy of Dramatic Art but chose to pursue a ten-year teaching career back in Dublin from his mid-twenties on. His film debut came in 1990 with a part in Jim Sheridan's *The Field* (1990). Since then he has featured in many of the key Irish films of the last two decades. Perhaps his greatest screen performance came in Martin McDonagh's elegiac gangster comedy/thriller *In Bruges* (2008), where his presence brought a sizable piece of Dublin to that part of lowland Europe. In his review of *In Bruges*, Roger Ebert described Gleeson as having a 'noble

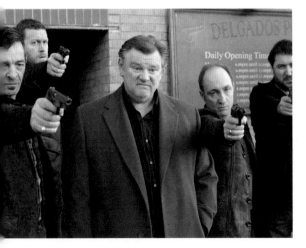

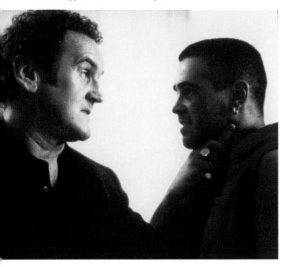

in *Intermission* that sees Farrell encounter Detective Jerry Lynch, played by Colm Meaney, with decidedly soggy results. Lynch is a fairly typical Meaney character; tough and abrasive yet bumbling and flawed, not a million miles away from his roles in the Roddy Doyle Barrytown adaptations. In particular his portrayal of the man-child patriarch in *The Snapper* (Frears, 1993) and *The Van* (Frears, 1996) successfully nailed the nature of a certain kind of suburban male Dubliner. More recently, Meaney explored the darker side of this archetype as ageing Dublin navvy Joe Mullan in Tom Collins' slice of London-Irish life *Kings* (2007). Of his own work he has said, 'I'm not a big method actor. I'm much more superficial.' This modesty veils the many years of hard work that Meaney has put into his career, having studied acting since the age of 14.

Meaney has shared screen time with fellow Dubliner Gabriel Byrne on two occasions: in Mike Newell's *Into The West* (1992), a tale of two young fugitives' flight from the slums of Dublin; and David Keating's Howth-set coming-of-age story *The Last of the High Kings* (1996). Byrne is frequently regarded as possessing a certain 'dark and brooding' side of Irish masculinity. This he disputes:

'In Ireland, brooding is a term we use for hens. A brooding hen is supposed to lay eggs. Every time somebody says, "He's dark and brooding," I think, "He's about to lay an egg."'

Like Meaney, Farrell and Gleeson, Byrne has enjoyed much international success, but has remained a staunch supporter of his homeland's culture and has been justly rewarded. He was appointed a UNICEF Ireland Ambassador in 2004 and in 2007 received a lifetime achievement award at the 5th Jameson Dublin International Film Festival. In the same year he received the Honorary Patronage of the University Philosophical Society of Trinity College Dublin.

Wherever their careers have taken them, these four faces of Dublin are so much a part of the place that one can almost envisage their likenesses carved, Mount Rushmore style, into the Cambrian quartzite of the Great Sugar Loaf; at least on a rainy day after a pint or two ... ✢

shambles of a face and the heft of a boxer gone to seed.'

Gleeson's *In Bruges* junior co-star, Colin Farrell, harks from Castleknock, a suburb some eight kilometres west of central Dublin. Born in 1976, his hometown experience reflects its recent changes. Of the city he has said:

'My Dublin wasn't the Dublin of sing-songs, traditional music, sense of history and place and community. It was kind of more *nouveau riche*, competition with the neighbours, a bit more privileged than the Dublin of lore.'

His career and behaviour have always seemed to veer from crass to quality; in 2003 alone he was named as one of People Magazine's 50 Most Beautiful People, was allegedly involved in the recording of a controversial sex tape with Playboy model Nicole Narain, had a son with US model Kim Bordenave and among several commercially successful Hollywood films also found the time to star in John Crowley's excellent *Intermission* (2003), one of the best Dublin-set films of the last ten years.

There is a memorable scene in a men's urinal

**Like Meaney, Farrell and Gleeson, Byrne has enjoyed much international success, but has remained a staunch supporter of his homeland's culture and has been justly rewarded.**

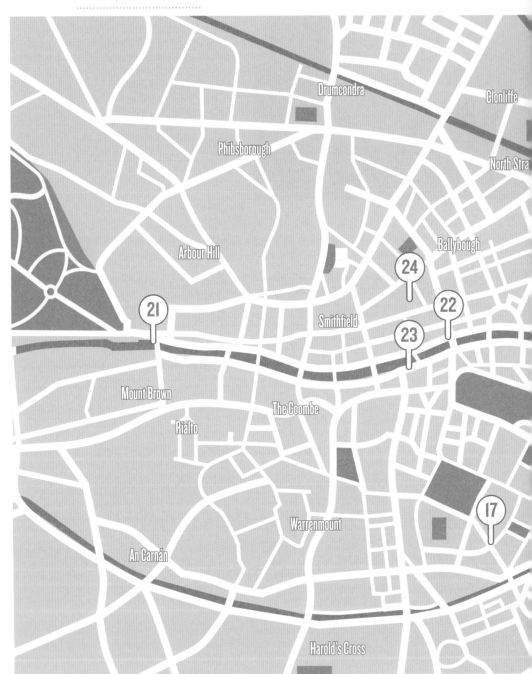

# LOCATIONS
## SCENES 17-24

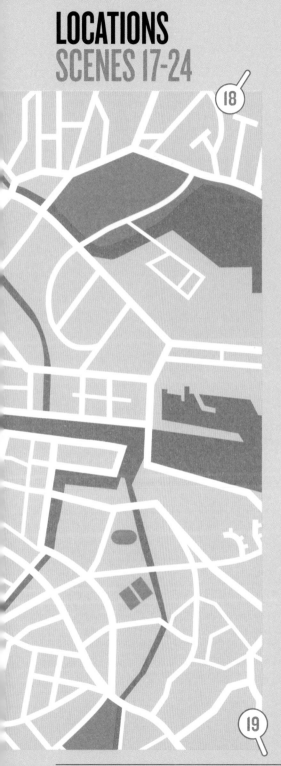

# THE VAN (1996)

LOCATION

*Buck Whaley's Nightclub, Leeson Street, Dublin 2 (exterior);*
*The Harp Bar, O'Connell Bridge, River Liffey, Dublin (interior)*

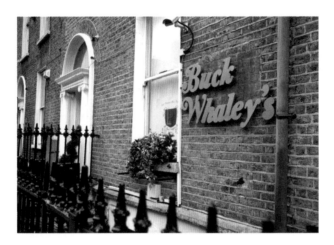

**THE LANGUAGE OF A** scene set in a slick Southside wine bar contrasts sharply with the earthy richness of the dialogue used in the Northside scenes that feature in *The Van*. Director Stephen Frears shows the nervousness of Larry (Colm Meaney) and Bimbo (Donal O'Kelly) before they enter the bar. They look uncomfortable in their smart suits and feel that they have to behave in a way that befits this city nightspot, a world away from The Hikers, their local Barrytown pub. Larry's behaviour is over-compensatory; he is desperately trying to fit in with Southside pretensions in order to impress a couple of ladies. He tastes the wine; his intention is to look like a wine connoisseur, but instead it looks like he is using mouthwash. He doesn't really like the taste of the wine and is shocked by the cost of it – he'd much rather be drinking Guinness. The wine bar scene demonstrates that the city promises more than it delivers. Larry and Bimbo hope that Dublin will be like an adult playground where they can find excitement away from the daily grind of their work on the chipper van, give them a chance to pull women, and in so doing dispel the rising tension in the friendship. Frears depicts the city as a corrupting and shallow place where people behave uncharacteristically. This depiction of Dublin contrasts starkly with the rich interactions between the people of Barrytown; a place where friendship, community and marriage mean more than having lots of money. **⚭Caroline Whelan**

(Photo © Patrick Swan)

*Directed by Stephen Frears*
**Scene description: Larry and Bimbo in the wine bar**
**Timecode for scene: 1:06:06 – 1:08:14**

# I WENT DOWN (1997)

LOCATION *Dowling's of Prosperous, Co. Kildare (interior)*

**AN EARLY BARROOM SCENE** in Paddy Breathnach's gangster road movie *I Went Down*, pointedly avoids a setting in tune with the received notions of Irish pubs as whimsical, wood-paneled 'craic houses' full of cherry-nosed, tweed-clad poets and bearded bodhrán-wielders. This is the sort of anonymous cinderblock community bar cum disco where serious drinking is done and the dealings are as shady as the pints. Having been abruptly dumped by his girlfriend while in prison – where he has just done a stretch for a crime actually committed by his drunkard dad – the mournful Git (Peter McDonald) pops round the pub upon his release to check out his competition, Anto (David Wilmot), only to run afoul of local Dublin crime boss Tom French (Tony Doyle) and get into an almighty scrap with his henchmen. We see Git and Anto on the morning after the night before, sat side by side on a brown leatherette sofa in the bar – the interior of Dowling's of Prosperous, Co. Kildare doubling for the Dublin barroom – receiving a verbal bollocking from French, who dispatches Git to Cork in search of a former confederate of his who has stolen a great deal of money from him. French is framed by a garish Mondrianesque grid of orange and yellow dance floor illuminations, while behind him there is a comically gothic tableau of patched up heavies and bar staff dragging vacuum cleaners across the carpet. This very static scene, charged with equal measures of *Lock, Stock...* style threat and humour, goes down a treat. ➟*Jez Conolly*

*Directed by Paddy Breathnach*
**Scene description: 'This is what I need you to do to make it right'**
**Timecode for scene: 0:07:15 – 0:12:01**

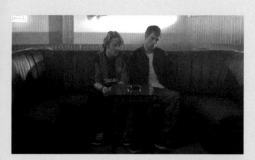
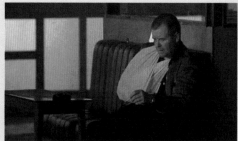

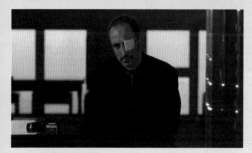
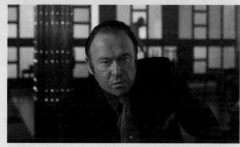

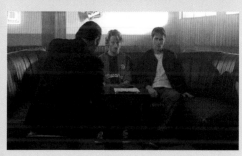
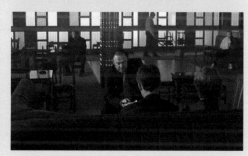

# THE LAST BUS HOME (1997)

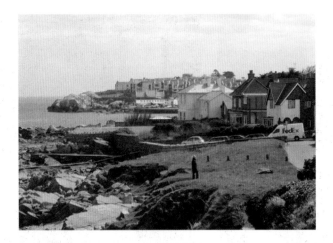

**IN THE CLOSING DAYS** of the 1970s, ambitious punkette Reena (Annie Ryan) meets aspiring musician Jessop (Brían F. O'Byrne). Within the confines of their conservative and religious surroundings, they share an angry youthful thirst for rebellion. Reena and Jessop fall for each other and together form the punk band The Dead Patriots. The opening scene of *The Last Bus Home* takes place during the Pope's historical visit to Dublin on 29 September 1979. The inhabitants of a suburban residential estate travel to the mass but Reena, much to the chagrin of her mother, refuses to go. Instead she aimlessly wanders around the eerily-deserted streets. In so doing she spots an advert in a shop window – 'Guitarist Seeks Band' – which has been placed by Jessop. Later that same day, Reena discovers him in a fruit and veg shop where he strums The Undertones' *Teenage Kicks* on an electric guitar. Out of budgetary limitations the majority of the locations used in *The Last Bus Home* were tightly blocked to keep the film firmly within its period setting. Therefore, it is ironic that the sequence illustrating Reena's oppressive surroundings takes place in a wide-open exterior space: the shots of the depopulated residential area are a reflection on her sense of alienation within the community. The cloudy sky is dark and foreboding while the buildings around Reena appear sterile and anonymous. It is this suburban setting from which The Dead Patriots are borne out of defiance in the face of social and parental conformity.
➙ *Christopher O'Neill*

(Photo © David Bagshaw)

*Directed by Johnny Gogan*
**Scene description: Reena and Jessop meet for the first time**
**Timecode for scene: 0:04:45 – 0:07:54**

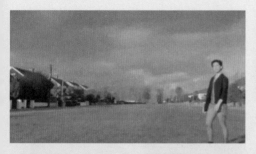

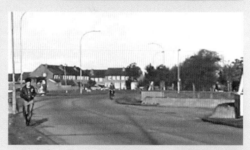

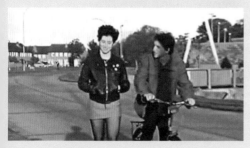

# THE GENERAL (1998)

LOCATION *The grounds of the Sheriff Street Flats, Sheriff Street, North Wall, Dublin 1*

**A TENT SITS SURREALLY** in the desolate grounds of Dublin's demolished Hollyfield estate, for which *The General* substitutes the Sheriff Street flats. The council is destroying the estate and the police are unforgiving enforcers. But Brendan Gleeson's Martin Cahill refuses to move. When they expelled him from his flat, he lived in a caravan. Now his caravan has been burnt down, he is living in a tent. Delegations of increasing size and importance have come to plead with him and, at last, the chairman of the housing committee arrives. Cahill agrees to relocate – but not to Kevin Street, the poor area where the rest of 'his kind' have been sent. He will only move to a spacious flat in Rathmines. The authorities, as they will throughout the film, know they are being manipulated. They are still defeated. The tent, standing defiant among the urban ruins, is a perfect metaphor for its occupant: a man capable not only of surviving but also of capitalising on chaos. The tent brings him the home he wants, and the spirit that erected it will allow him to exploit the turbulence in Irish society and make him 'a world class criminal and a working-class hero.' After this scene, which is just forty seconds long and occurs only eleven minutes into the movie, we can accept whatever daring and outlandish crimes Cahill is shown to commit, not because we know this is a true story – although it is – but because Gleeson has so utterly seduced us. ➻ *Scott Jordan Harris*

(Photos © Patrick Swan)

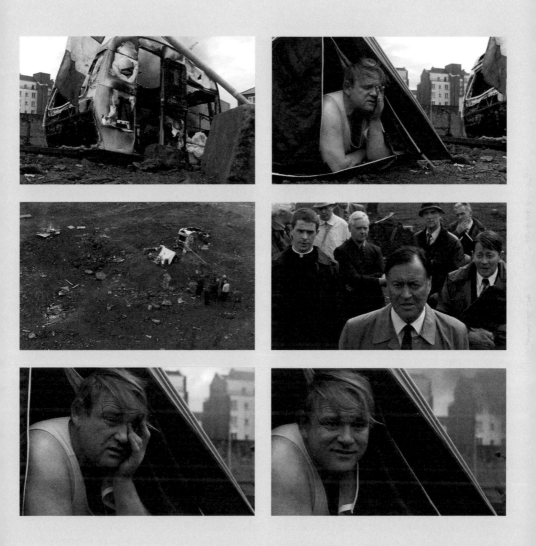

# ACCELERATOR (1999)

*Heuston Station, Dublin 8*

**VINNY MURPHY'S** *Accelerator* opens in the wasteland of an urban ghetto where joyriding is considered a way of life. Johnny T (Stuart Sinclair Blyth) is on the run from paramilitary vigilantes because of his antisocial behaviour. From the outset Johnny is a character on the cusp of change. Having admitted to joyriding in front of his community (before going on yet another spree) he seeks escape and heads for Barcelona, stopping off in Dublin en route. He meets Whacker (Gavin Kelty) who challenges him to a race, from Belfast to the Papal Cross in Dublin's Phoenix Park, a distance of about one hundred miles. The 'prize' of Louise (Aisling O'Neill), Whacker's girlfriend, and the sum of £1,200 convinces Johnny to rise to this challenge before finally hanging up his 'hot-wires' for the last time. The scene depicted shows the characters as they embark on their journey to Belfast. Shot in Heuston Street train station, the cinematography deliberately eschews any landmarks or recognisable features that will reveal the location. In a direct challenge to the dominant clichéd representations of Dublin, this film's visual iconography is one of the global urban city experience: industrial estates, wastelands, multi-storey car parks and unrecognisable public spaces. From bland shop shutters to vacant spaces, Murphy denies a romanticizing of the urban landscape. The only overt reference to somewhere recognisable is the papal cross in Phoenix Park. Alas none of the joyriders make it that far, for most their journey is cut short before they reach the border. **◆ Díóg O'Connell**

(Photo © Patrick Swan)

*Directed by Vinny Murphy*
**Scene description: Exiting Dublin, getting the train to Belfast**
Timecode for scene: 0:28:52 – 0:29:53

 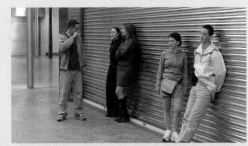

 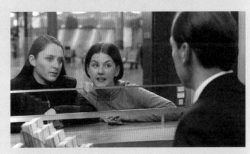

Images © 1999 Flashpoint/Imagine/Two for the Road

# AGNES BROWNE (1999)

LOCATION *Clery & Co., 18-27 Lower O'Connell Street, Dublin 1*

**THE BROWNE FAMILY** shopping trip to Clerys, the oldest department store in Dublin, is preceded by a scene of Agnes (Anjelica Huston) and best friend Marion (Marion O'Dwyer) discussing 'organisms' – Agnes's late husband being useless in that department – as only Moore Street Market women might, and followed by one of Agnes at home enjoying a sexy private dance. Sandwiched between these moments, the shopping scene is an important early turning point in the film. The Brownes have come to Clerys to choose Agnes' daughter's confirmation dress, and as the family leave the shop they notice a glamorous blue frock in the window. It seems like an impossible dream to have this dress and indeed Agnes' eldest son declares that it is 'not a mammy's dress'. Still outside Clerys, Agnes has a serendipitous exchange with fellow Moore Street trader Pierre (Arno Chevrier) – 'you look lovely today' – with the Clerys clock visible in the background. The clock is a traditional meeting place for lovers in Dublin and is an indicator of the romance that will follow. The Clerys dress symbolizes how the city can lure people into wanting things they cannot afford, yet it also provides Agnes with an escape from the drudgery of being a widowed working mammy. Her needs and sexuality are being explored along with her roles as mother and market trader. She later gets to have the dress *and* a date with Pierre, but only after one of her sons has borrowed from a greedy moneylender (Ray Winstone) to pay for it. ➙*Caroline Whelan*

(Photos © Patrick Swan)

*Directed by Anjelica Huston*
Scene description: Agnes and family outside Clerys department store
Timecode for scene: 0:31:33 – 0:32:40

# ABOUT ADAM (2000)

LOCATION *Temple Bar, Dublin*

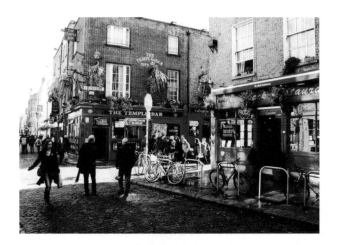

**TWO LOVERS, THE SMOOTH** Adam (Stuart Townsend) and the bubbly Lucy (Kate Hudson) make love on a rooftop under the stars. The scene captures the exuberant mood of a Manhattan location. Except this is a Dublin rooftop. Stembridge's *Rashomon*-style sex comedy bursts free from decades of sexual repression and economic recession to march Irish film into a new era of confidence and prosperity. The film, with its clamour of bright colours and modern Dublin locations, portrays the city with a glitz and glam it had never previously enjoyed. The film operates, too, with a sense of abandon born of liberation. The archetypal Adam is a chameleon charmer who first seduces Lucy, then her sisters Laura (Frances O'Connor) and Alice (Charlotte Bradley), her mother (Rosaleen Linehan) and her brother David (Alan Maher). Unlike the self-consciousness of the past, the film is bright and breezy, bereft of the shackles of sexual guilt. Adam is revealed gradually as a pathological liar, but the film also presents him as an enabler: these modern Irish women have sex and nobody makes a fuss over it. As the couple clutch on the rooftop under the stars, the camera cranes upwards and across to reveal they are on top of a building in Dublin's Temple Bar district, the bustling hub of city regeneration and new-century confidence. The scene cuts to a sunrise shot of the Dublin skyline framed by a construction crane – an intimation of the cluttered city sky that would dominate Dublin's Celtic Tiger years. **⇢Paul Lynch**

(Photo © Brendon A. Smith)

*Directed by Gerard Stembridge*
*Scene description: Couple make love on a rooftop in Temple Bar*
*Timecode for scene: 0:12:00 – 0:12:16*

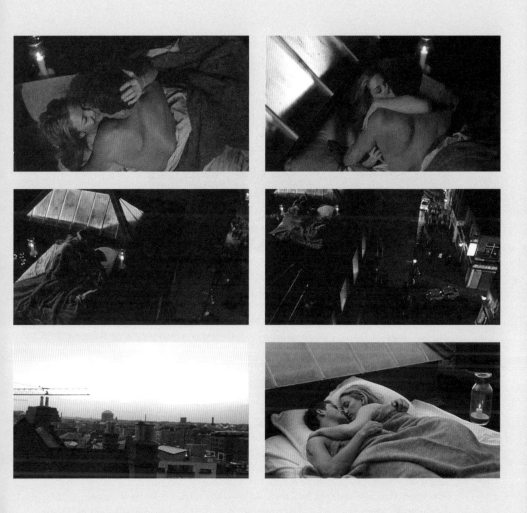

# NORA (2000)

**LOOSELY BASED ON** Brenda Maddox's 1988 biography *Nora: The Real Life of Molly Bloom*, Pat Murphy's film tells the story of the love affair between James Joyce and Nora Barnacle from when they first met in 1904 until 1912, when they depart from Ireland, unmarried with two children in tow, never to settle again on their native soil. The narrative focuses on their life together as they struggle in a new country, living together and apart, and the role Nora plays in Joyce's writing. Similarly to her other feature films, *Maeve* (1981) and *Anne Devlin* (1984), Pat Murphy brings a feminist perspective to bear on the film's narrative, yet in a newly imagined way. *Nora* opens in 1904 when Nora Barnacle (Susan Lynch) runs away to Dublin from her native Galway. Joyce (Ewan McGregor) first spots Nora as she strolls along a bustling Dublin shopping street. Evoking a small, localised milieu, Joyce knows that she is a stranger in town and guesses from her accent that she hails from Galway. Nora from the start is confident and assertive. When Joyce introduces himself and arranges a date but fails to ask her name, she calls after him: 'Hey James Joyce, don't you want to know my name? ...My name is Nora Barnacle.' The scene anticipates the place Joyce will give to the streets of Dublin in his later writings but Pat Murphy privileges Nora in the story, giving her a central narrating voice. ⊷**Dióg O'Connell**

(Photo © Patrick Swan)

*Directed by Pat Murphy*

Scene description: *First encounter – James Joyce and Nora Barnacle*
Timecode for scene: *0:03:25 – 0:04:42*

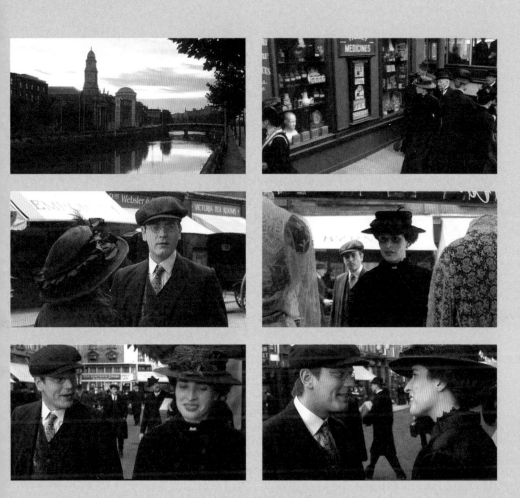

# DUBLIN

*A Stage for Revolution?*

Text by
ADAM
O'BRIEN

**FEW HISTORICAL UPRISINGS** can be easily sandwiched between start and end dates, and the Irish fight for independence in the twentieth century is a case in point. One could even argue that conflicting opinions on what constitutes the 'end' of the struggle are at the heart of the tragedy and pain which ensued. Films depicting the movement, of course, have to make some kind of decision on this, and the period between 1916 and 1923 holds a special grasp on cinema's imaginative reconstructions of the events. But pinpointing *when* to locate huge historical events is only the half of it; cinema, by its very nature, is also obliged to choose *where* to locate them. And the city of Dublin has played an important, if somewhat ambiguous, role in this. As a capital city, the site of the Easter Uprising, the location of the first IRA convention and the seat of British rule, it cannot help but be a part of the story, and yet Dublin can remain oddly peripheral to the drama. Films about the French Revolution may offer an interesting counterpoint, for while *La Marseillaise* (Renoir, 1938) and

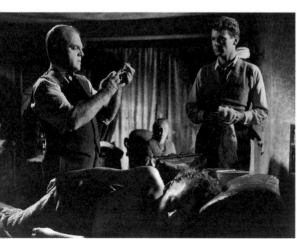

*The Lady and The Duke* (Rohmer, 2001) – to name but two – are deeply concerned with Paris and Parisians, *Michael Collins* (Jordan, 1996) and *Shake Hands with the Devil* (Anderson, 1959), for example, do not depict the struggle against British rule as emanating *from* Dublin, regardless of how many scenes take place *in* Dublin. Whilst fully aware of the importance of the city, these films are not concerned with identifying it as the historical epicentre of the Irish republican cause.

*Michael Collins*, Neil Jordan's wildly successful biopic starring Liam Neeson and Julia Roberts, is probably the best-known film about the period. Its prologue is something of an expressionistic reconstruction of the Easter Uprising, indulging in its mythic status, rather than rooting us in a time or a place. And despite the lavish sets recreating period Dublin (which Jordan actually opened to curious Dubliners), the film does not go on to generate much of a dynamic between 'everyday' citizens and the momentous events sweeping through the city. Understandably, Jordan was mainly set on investigating those mysterious political machinations which took place behind closed doors, in secret headquarters, prisons and exclusive hotels. Yet even when the conflict really is played out on the streets, as in the symbolic attack on the Custom House, Jordan's depiction is eerily void of passers-by. Dublin is more of a site than an active agent.

John Ford's *The Informer* (1935) is, in this sense at least, the direct opposite of *Michael Collins*. Less interested in the major historical figures of the struggle than the suffocating atmosphere of the city – it is an early example of film noir – Ford's film is one in which Dublin's pubs and streets, its people and its geography, are what matters. Perhaps this is at the expense of the 'history' (if we define

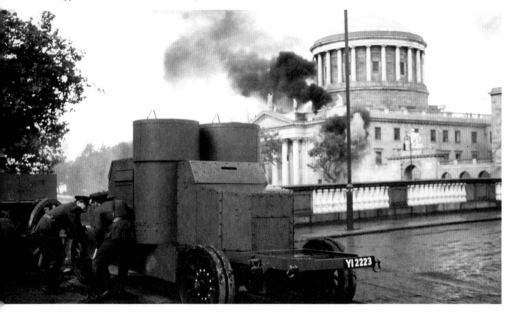

that word according to names and dates), and one cannot help but feel a little patronised by *The Informer*'s rather straightforward take on such difficult and complex issues, as themes of innocence and loyalty are sifted through a rather shallow plot. But its spirited attempt to evoke something of Dublin's sense of paranoia and threat during this time is hard to ignore.

If *Michael Collins* chooses historical accuracy over urban atmospherics, and *The Informer* vice versa, then *Shake Hands with the Devil* falls somewhere between the two. Like *The Informer*, its Dublin is full of menacing shadows and smoke-filled alleys, but like *Michael Collins* its thematic ambition takes it far beyond the city. In it, James Cagney plays Sean Lenihan, a bitter and brutal republican whose thirst for bloody revenge poisons his principles. Although he lives and works in Dublin, much of the film shows Lenihan patrolling rural Ireland, organising his troops from a dilapidated farm shed or an isolated lighthouse. The film's director, Michael Anderson, takes every opportunity to characterise the struggle as an exercise in nation building rather than urban insurrection; rolling hills and

> **In these historical films, Dublin is both vital and peripheral, influential and beside the point.**

dramatic beachscapes ensure we understand this as Ireland's history, and not just Dublin's. Its tone is not dissimilar to Samuel Goldwyn's production of *Beloved Enemy* (Potter, 1936), in which the film's hero, Dennis Riordan (Brian Aherne), dreams of, 'a farm in County Galway, with some fine pigs and horses belonging to it.' The scene is a fascinating one; Riordan is supposed to be escorting an English aristocratic lady back to Dublin, but is mischievously leading her away into the countryside, toward the Ireland in which he can apparently be himself. And one in which, of course, he can fall in love. Seventy years later, in the infinitely more bitter *The Wind That Shakes the Barley* (Loach, 2006), the approach to setting is not all that different, with Loach placing the action firmly in the country – in both senses of the word.

In these historical films, Dublin is both vital and peripheral, influential and beside the point. We are not encouraged to indulge in its attractions, as we so often are with New York, London and Paris, and yet this approach creates its own layers of subtlety and fascination. The very fact that Dublin tends *not* to be co-opted as an icon or shorthand for revolutionary drama means that we, as an audience, have to work a little harder to place it in the historical picture. ✢

# DUBLIN

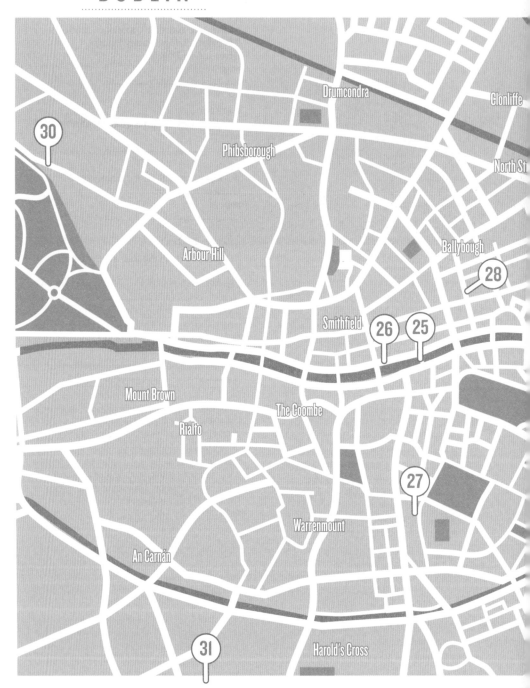

# LOCATIONS
## SCENES 25-32

# ORDINARY DECENT CRIMINAL (2000)

LOCATION *'Ha'penny Bridge' (Liffey Bridge), River Liffey, Dublin*

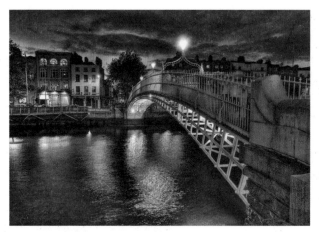

**THADDEUS O'SULLIVAN'S** veiled retelling of the Martin Cahill story – Kevin Spacey's Michael Lynch is The General in all but name – offers a varied picture of Dublin: that of the benefits office, kerbside plotting and new-build housing estates, as well as the seminary and art gallery. The one truly iconic bit of Dublin he allows us a glimpse of is saved for a pivotal scene of the gang going their separate ways. It takes place on the 'Ha'penny Bridge', a bottleneck route over the Liffey (Gaelic for 'life') in Dublin's centre. The scene on the bridge is a literal and metaphorical one of division and the taking of different paths. The gang are pursued at a trot by the Gardaí, who have enacted a strategy of up-close harassment. Temporarily ahead of the pursuing pack, the gang hastily discuss their plans and emphasise their impending rift as they cross the landmark. Michael and his cohorts pause at the other side of the bridge as their pursuers catch them up. It becomes clear that the rift in the gang is irreparable and they are going to follow different directions, the bridge being as narrow as their options. As the plainclothes Gardaí surround them, their divisions are made clear. Michael turns and walks back over the bridge with two officers now following him, also forced to choose a direction – along the bridge across the river of life. Without his dissenting gang we feel that Michael is once again leading the way unpursued, his path back the way he came now clear. **David Bates**

(Photos © Patrick Swan)

*Directed by Thaddeus O'Sullivan*
*Scene description: The gang's rift becomes real while crossing the Ha'penny Bridge*
*Timecode for scene: 0:59:57 – 1:01:26*

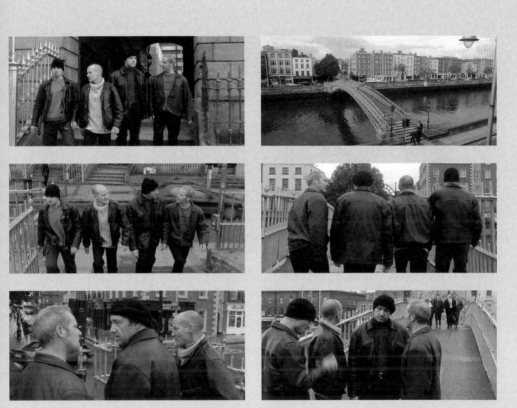

# RAT (2000)

*The Four Courts, Inns Quay, Dublin 7*

**DIRECTOR STEVE BARRON** provided a suitably daft climax to a chase scene in his cheerfully Kafkaesque curio *Rat*, managing to soak one of Dublin's architectural hallmarks with the city's most synonymous alcoholic beverage (established 1759) in the process. For reasons unknown humble baker's delivery man Hubert Flynn (Pete Postlethwaite) has turned into a fine, fat and furry example of *Rattus norvegicus*. In an attempt to rehabilitate him into the community his family, headed by his wife Conchita (Imelda Staunton), the comic distillation of every bassinette-pushing Dublin Mammy, decide to take the now-whiskery *pater familias* to some of his erstwhile favourite haunts. After being shown the door at the bookies the family finds a warmer welcome at Hubert's local pub. No sooner has Hubert climbed into and downed a pint of his beloved Guinness than he affects his escape out into the cobbled streets of central Dublin with his family in hot pursuit. Hubert picks the wrong moment to cross the road in front of the famous Four Courts building on Inns Quay, and narrowly avoids ending up under the wheel of a Guinness delivery lorry. The vehicle jackknifes and spills its load of barrels, some of which burst open, showering the bewigged barristers gathered on the steps of the courthouse with several gallons of the Black Stuff. Amid the liquid carnage Conchita spots her spouse-rodent happily supping at the spillage that now runs in the gutters. **➦Jez Conolly**

(Photos © Patrick Swan)

*Directed by Steve Barron*
*Scene description: The Four Courts caught in a shower of Guinness*
*Timecode for scene: 0:29:22 – 0:30:14*

 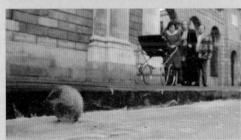

# WHEN BRENDAN MET TRUDY (2000)

LOCATION *Unknown interior of Dublin apartment*

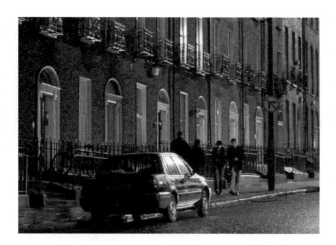

**THE RODDY DOYLE-PENNED** *When Brendan Met Trudy* is predominantly a lighthearted odd-couple romance brimming with film related in-jokes and references, but it also captures the social, political and cultural climate of the Celtic Tiger boom years. Uptight, traditional teacher Brendan (Peter McDonald) and happy-go-lucky professional thief Trudy (Flora Montgomery) embark on a life-altering affair within an evolving and economically prosperous Dublin. Played out in a variety of locations including O'Connell Street, Kavanagh's bar and the city's busy nightspots, the most focused representation of the Dublin being portrayed comes as Trudy invites Brendan to a friend's party. Interior design, ethnic diversity, fashion and script form a pointed *mise-en-scène* where the stoical, conservatively dressed Brendan, the face of old Dublin, is presented with the upbeat, hedonistic attitudes and contemporary style of the emerging modern Dublin. The spacious flat contains wood panelled flooring, art hanging from every wall, designer lighting and a thoroughly bohemian set of guests. Via Brendan's conversation with Edgar (Maynard Eziashi), a Nigerian refugee whom he mistakes for a medical student, the scene touches on immigration, newfound affluence, aspiration and cultural regeneration, all of which the city as a whole experienced during this period. The Guinness and Irish brogue may still be present but in this interior location, a microcosm of the outside city as a whole at the time, new imported forces have merged with existing traditional elements to symbolize the changing internal outlook and physical external appearance of Dublin. ➤**Neil Mitchell**

**Above** Shot from the film showing the exterior of the apartment block

*Directed by Kieron J. Walsh*
**Scene description: Trudy takes Brendan to a party**
Timecode for scene: 0:15:40 – 0:19:11

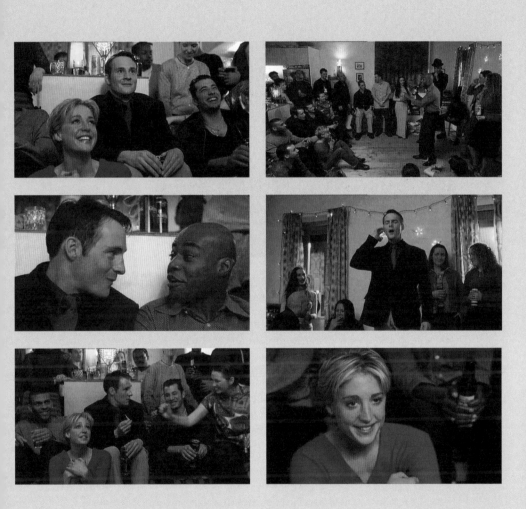

# BLOOM (2003)

LOCATION *St. Mary's Pro-Cathedral on Marlborough Street*

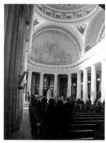

**SEÁN WALSH'S VERSION** of Joyce's *Bloom* truly explodes into life during the Nighttown sequence, beginning around St. Mary's Pro-Cathedral on Marlborough Street. Structured as a play complete with stage directions in the novel, Walsh's direction manages to wonderfully evoke the surreal and spiralling fantasies endured by Leopold Bloom, with the scene erupting in a carnivalesque miasma of hallucinogenic colour while anchored with a vigorous undercurrent of sexuality. Bloom flits through a variety of guises ranging from male and female to peasant and regal, casually fondling ladies of the night, before finding himself at the mercy of an opulent courtroom where Bloom's litany of sexual misdemeanours are recounted to mass hilarity. Walsh's depiction of the freewheeling court sequence is a perfect cinematic realization of Joyce's work as it manages to capture the humour and pathos while adhering to the wonderful directions outlined within the novel. As the judge pledges to rid Dublin of 'this odious pest', Bloom suddenly launches into a bizarre monologue concerning transmigration of the soul before finding himself declaring his maternal instincts to the courtroom. It is testament to Walsh's direction that the juxtaposition of such a series of seemingly unrelated events are effortlessly dealt with as the camera work glides from one fantasy to another, straddling the boundaries between humour and horror. **↦Colm McAuliffe**

(Photos © Patrick Swan)

*Directed by Seán Walsh*
**Scene description: Bloom's mind goes astray as he succumbs to hallucinations in 'Nighttown'**
**Timecode for scene: 1:06:02 – 1:17:42**

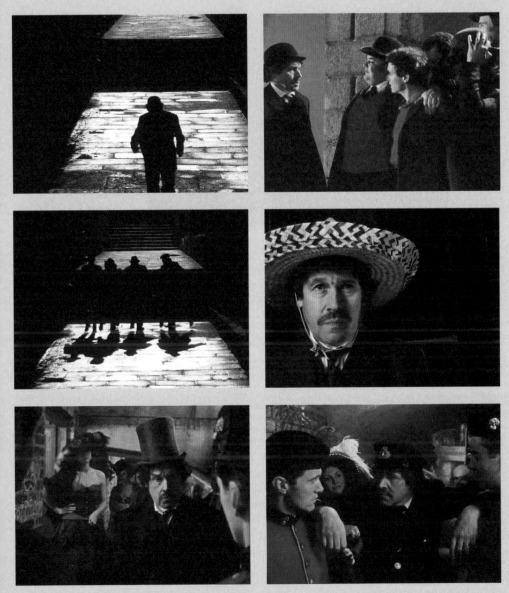

# GOLDFISH MEMORY (2003)

*Ocean Bar & Restaurant, The Millennium Tower, Ringsend, Dublin 4*

**THE TOP AND TAIL** of this scene – an initial aerial shot of Dublin and a tracking shot coming to rest on a large bowl of goldfish – display a confident glow as orange as the third band of the Irish Tricolour, or the stripes on a tiger's back for that matter. The opening scene within an upmarket café bar is our first sight of the location employed as a centrepiece throughout the film. Grand Canal Dock, the area of Dublin's rejuvenated inner city, serves as a backdrop for the bar's young and vibrant customers, and here we see the film's protagonists among them. Grand Canal Dock and its accompanying eateries and coffee shops are entirely representative of urban regeneration during the Celtic Tiger, and Liz Gill employs the location in order to generate a European feel to the city of Dublin. Yet the choice of location does feel rather generic, lacking in any local flavour; a critique directed at a number of Irish films of the 2000s such as *About Adam* (Stembridge, 2000). Just like the characters within the film, the interior of the café bar is depicted as fashionable, shiny and cool, if rather vacuous; an unintentional critique of Celtic Tiger Ireland. Given the recent economic downturn within the Republic of Ireland, the representation of Grand Canal Dock in the scene must be viewed as very much a product of its time. **⤏Stephen Boyd**

(Photo © Andrius Burlega)

*Directed by Elizabeth Gill*
**Scene description: How the Celtic Tiger got its stripes**
**Timecode for scene: 0:1:15 – 0:02:30**

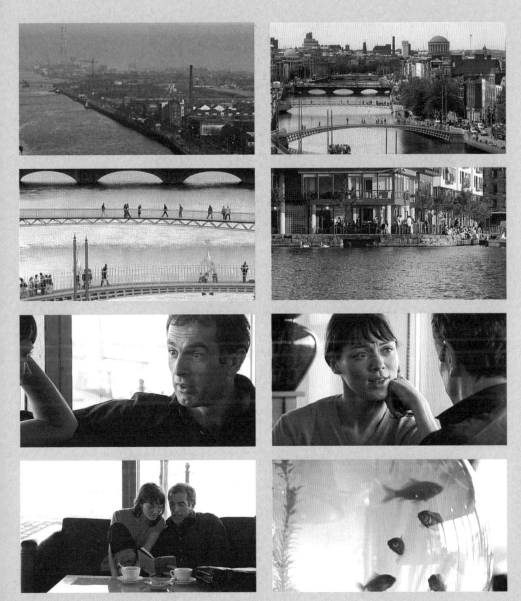

Images © 2003 Goldfish Films

# INTERMISSION (2003)

LOCATION Springfield, Dublin 7

**DESCRIBED BY CRITIC** Richard Roeper as being 'a likeable film about nasty people', John Crowley's *Intermission*, through its multiple interweaving narratives and insular characters, portrays Dublin as a small town. Though the characters may be broad in spectrum, from petty criminals via the disaffected working-classes through to aspirational documentary film-makers, they are shown to co-exist in close proximity where the private is very often made public. Crowley's approach to representing the city is highlighted by the Dublin-centric 'Little Big City' TV show that forms an integral part of the overall narrative. The themes addressed in *Intermission* – local lives, gossip, petty crime, chance and coincidence, all carried out off the tourist trail – converge when a bus crash acts as a catalyst to bring the narrative strands together. Filmed on the outskirts of the Springfield estate of South Dublin, a highly populous residential area, an act of wanton vandalism ruptures the humdrum of day-to-day existence. Partly recounted in flashback during an awkward family meeting, the split scene cuts between the bus and house interiors and the road exterior used to stage the accident. The sequence moves from comedic banter through unexpected disruption to familial tensions, highlighting the close-knit but fractious environment, unexpected events and social mores affecting the average Dubliners that *Intermission* focuses on. The city through Crowley's eyes is a place where landmark locations are for visitors, the outside world rarely penetrates and where its heart and soul is found in the minutiae of everyday life. **Neil Mitchell**

(Photo © Patrick Swan)

*Directed by John Crowley*
**Scene description: The bus crash**
**Timecode for scene: 0:21:10 – 0:26:38**

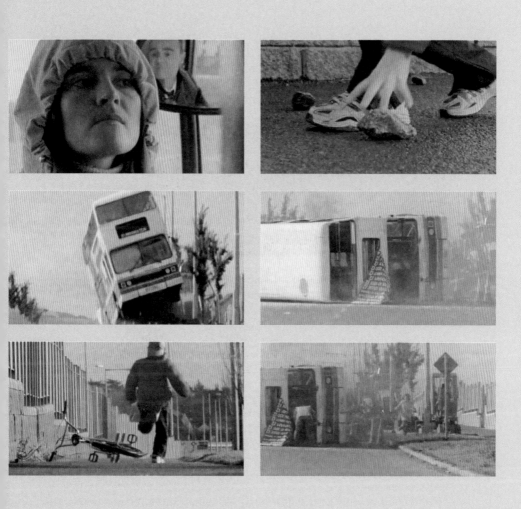

# THE ACTORS (2003)

LOCATION *Humewood Castle, Malahide Castle and the countryside around Wicklow*

**SOME OF THE DREAMIER** locations around Dublin are put to good use as a composite imagined place in Conor McPherson's *The Actors*, a film that leads its audience through a contemporary comedy of errors that takes the concept of false identity to a whole new level. Adapted from a story by Neil Jordan, *The Actors* sports a star-studded cast eminently led by Michael Caine and *Black Books'* Dylan Moran. Caine plays struggling thespian O'Malley, who is appearing at the Olympia Theatre as a Nazi Richard III in what is clearly a disastrous production. O'Malley recruits another equally struggling thespian, Tom (Moran) to assist him in conning £50,000 out of a retired small-time local gangster brilliantly characterised by Michael Gambon. The tale is told partially through the eyes of Moran's slightly creepily intelligent 9-year-old niece, Mary (Abigail Iversen), who has to step in on several occasions to save our fumbling heroes when their plans inevitably go awry when Moran is forced to assume the guise of various hapless characters, not least the carefully crafted second-hand car salesman of a criminal, Clive. As a result, the locations are often magical and, bearing the exaggerations of a child's perspective, create a subtly innocent backdrop. None more so than the fictional Tubbetstown Castle, in reality a combination of several locations including Humewood Castle, Malahide Castle and the stunning countryside around Wicklow. These are seamlessly stitched together to create the setting for the film's key scene: the wonderfully farcical demise of Clive. **➻Lisa Shand**

(Photo © William Murphy)

Directed by Conor McPherson
Scene description: The brilliantly farcical demise of Clive
Timecode for scene: 0:49:58 – 0:56:14

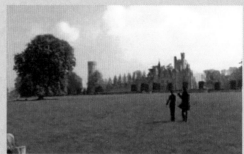

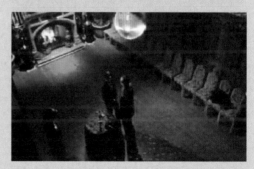

Images © 2003 Film Four/Scala Prods

# VERONICA GUERIN (2003)

LOCATION *The Great South Wall leading to Poolbeg Lighthouse, Dublin Bay*

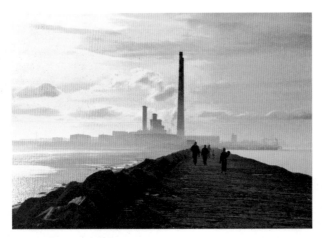

**POOLBEG LIGHTHOUSE** stands at the end of the Great South Wall, a long, thin finger extending some four miles from the smokestacks of Ringsend, along through the Southside quays and out into Dublin Bay. From here the 360 degree views across the bay to Howth, south to Dalkey, and to the Sugar Loaf Mountain have long been enjoyed by Dubliners seeking fresh air and an escape from the city's hurly-burly. Investigative journalist Veronica Guerin (Cate Blanchett) has been keeping a watch on the city for some time and, knowing that her investigations have put her life in danger, there is some sense in coming to this isolated spot where she can hope to keep everything and everyone in her sights. It is here that she has her final meeting with John Traynor (Ciarán Hinds) her double-dealing contact with Dublin's criminal underworld. She tells Traynor that she's planning to write a piece for the Sunday Independent that will expose his money laundering links. His exhortations at this news serve to implicate him, all of which is caught on camera by the waiting Gardaí, and on tape through the wire Guerin is wearing. In this moment of entrapment Guerin's own fate is sealed. She reached the literal end of the road to meet Traynor on the Great South Wall that day. Soon after, as a result of her attempts to expose corruption, she will end her days, assassinated in her car on the Naas Dual Carriageway near Newlands Cross. **→ Jez Conolly**

(Photos © Patrick Swan)

*Directed by Joel Schumacher*
**Scene description: Guerin's last meeting with John Traynor**
*Timecode for scene: 1:12:02 – 1:14:43*

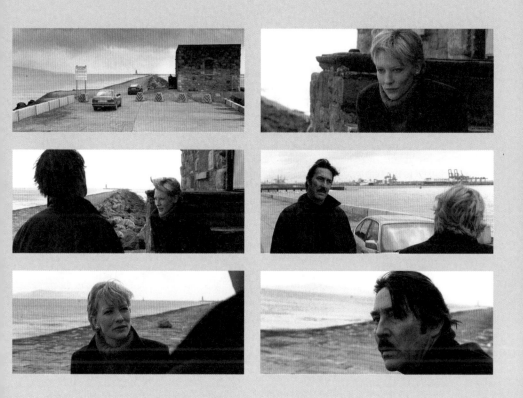

# URBAN VISIONS AND CINEMATIC MODERNITIES

*Literary Dublin On-screen*

Text by
COLM
McAULIFFE

**THE MODERN NOTION** of the narrative film is due to literature. From the use of nineteenth century novel techniques such as the 'Institutional Mode of Representation' through the interweaving literary intertextuality of art house cinema, the relationship between literature and cinema is indelibly linked to the history of cinema itself.

The urban streets, bridges, monuments and buildings throughout the city of Dublin serve as façade for all sorts of public and private interiors as evinced by the city's remarkably rich literary history. In 1909, James Joyce opened the Volta, one of Ireland's first dedicated cinemas in Mary Street, Dublin. It is a rather fitting connection as Joyce attempted to map out the psychogeography of his home town through the flaneur-like ramblings of Leopold Bloom in *Ulysses*, deploying a whole range of techniques such as montage and rapid scene dissolves which are more commonly associated with cinematic techniques.

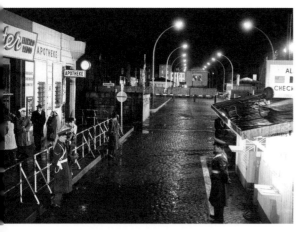

Dublin city had been vastly represented on theatre through the beginnings of the twentieth century through the successes of Sean O'Casey and J.M. Synge. With the advent of cinema and modernity, adaptations of literary heavyweights rarely, if ever, used Dublin itself as a backdrop as studios preferred the more sanitized and cardboarded sets offered by Hollywood which often offered unintended laughs through wildly inaccurate imitations of Dublin accents and incredibly naïve captions.

By the early 1960s, this toning down of literary works was beginning to ease somewhat as Arthur Dreifus filmed his version of Brendan Behan's *The Quare Fella* in the grounds of Kilmainham Jail, featuring a pre-*Prisoner* Patrick McGoohan as a sheltered and gullible prison warder. Shot entirely in black and white, Dreifus offers a remarkably austere adaptation of Behan's play – it is possible at times to see the actors' breath - although the general anarchy is rather muted to make room for these prison sequences.

Jean Baudrillard famously remarked 'Where is the cinema? It is all around you outside, all over the city, that marvellous continuous performance of films and scenarios.' With this in mind, it took an idealistic American named Joseph Strick to fully realise the cinematic potential of Dublin's sprawling and complex geography. After years of frustration, Strick managed to film the first and arguably definitive version of Joyce on screen with his 1967 adaptation of *Ulysses*.

While criticised heavily on release for not using the original 1904 setting of the novel, Strick's attempt can now be viewed as a magnificent achievement, bringing

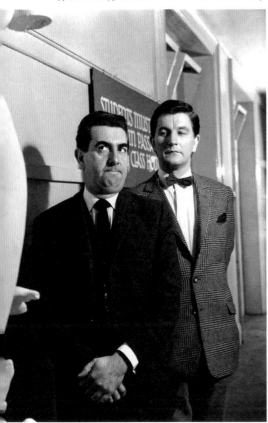

John Le Carré's espionage classic *The Spy Who Came In From the Cold* (1965) starred Richard Burton as Alec Leamas, an obstinate agent who is trusted with a perilous mission in early Cold War Berlin. The famous Smithfields market, which operated by day as an inner city market replete with livestock, now served as the Berlin Wall with the centrepoint as a makeshift yet effective Checkpoint Charlie.

Smithfields is located immediately north of the River Liffey and indeed the north side of Dublin city has arguably been represented on film to a much greater extent than its more prosperous side on the south. The emergence of Roddy Doyle in the late 1980s as an inspirational chronicler of working-class Dublin and his highly inventive and evocative dialogue facilitated the transition of colloquial text to cinema screen.

The opening sequence from Doyle's *The Commitments* (Alan Parker 1990) follows Jimmy Rabbitte as he takes the viewer on a tour through his Dublin, as he attempts to sell t-shirts at the stalls on Sherriff Street while the area buzzes with local vendors, fiddle players and young boys signing sean-nós amidst the carnivalesque air. Music plays an integral part throughout the narrative as we encounter Procul Harum's 'A Whiter Shade of Pale' played on the organ at St. Francis Xavier's Church on Gardiner Street, the early band practices in a snooker hall on Lower Camden Street and the eventual disintegration of Dublin's self-styled 'saviours of soul' on Sir John Rogerson's Quay, as they impatiently await the arrival of Wilson Pickett.

Of course, the spectre of W.B. Yeats haunts every aspect of Irish literature and his play, *Words Upon the Window Pane* (1994) was elegantly adapted by Mary McGuckian, who depicted the action shifting between a Dublin of the eighteenth and twentieth century at ease. As the spirits of Jonathan Swift and two of his lovers, Vanessa and Stella, disrupt a meeting of the Dublin Spiritualist Society, centering upon Trinity College as the president of the society, a University academic, presides over a series of surreal séances with the action effortlessly glides between the opulent grounds of Trinity itself along with Dublin Castle, Christchurch, Temple Bar and Grand Canal Docks. ✛

the city's aesthetic dimension to the fore as his black-and-white cinematography ensures Dublin becomes a character in the film with O'Connell Street, the Ha'penny Bridge and Glasnevin Cemetery serving as timeless mise-en-scene without falsifying the city's burgeoning modernity. Richard Karn remarks that the varied topographies of seascapes, landscapes and urbanity allows it to 'convey the same effect of the book, an atmosphere of teeming life in a shabby environment'.

**A much more unlikely cinematic evocation of Dublin in the 1960s came with added Hollywood A-list glamour.**

A much more unlikely cinematic evocation of Dublin in the 1960s came with added Hollywood A-list glamour. Paul Dehn and Guy Trosper's adaptation of the pseudonymous

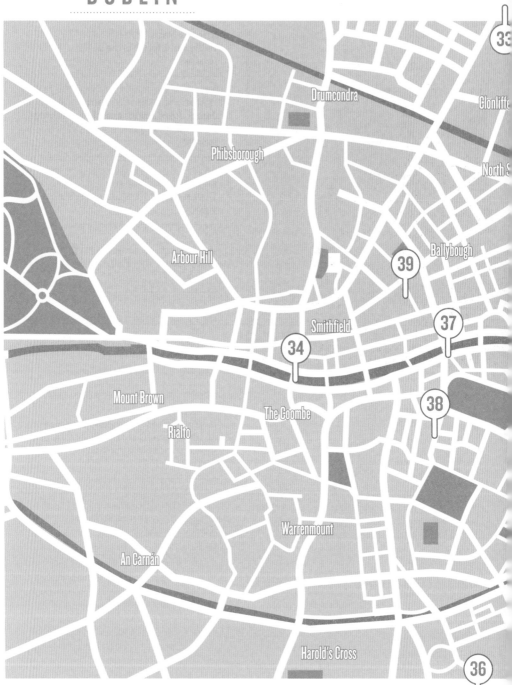

33

Drumcondra

Clonliffe

Phibsborough

North S

Arbour Hill

Ballybough

39

Smithfield

37

34

Mount Brown

38

The Coombe

Rialto

Warrenmount

An Carnán

Harold's Cross

36

# LOCATIONS
## SCENES 33-39

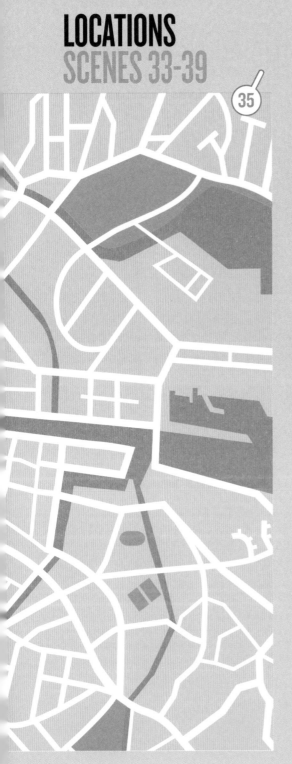

# ADAM & PAUL (2004)

*Ballymun Flats, Northside*

**LENNY ABRAHAMSON'S** jet black comedy about 24 hours in the life of two hapless junkies features an early sequence that squarely locates it as dealing with the underbelly of Dublin life. Scripted by Mark O'Halloran, who plays Adam, the alternately bleak, poetic and affectionate portrait of those on the margins of Dublin's society takes us into that world via the pair's abortive attempt to score heroin at the notorious Ballymun Flats. Built during the 1960s in Dublin's Northside area to re-house inner city residents after slum clearances, the ugly concrete high-rises fell prey to drugs, crime, delinquency and disrepair over the following decades. The largely working-class inhabitants of the flats faced postcode discrimination from non-residents and potential employers, a tale replicated in many cities for those from less desirable addresses. Shot by Abrahamson just before scheduled demolition and regeneration work began on the seven towers, the visual tone and atmosphere of the film is set by the graffiti, abandoned shopping trolleys, bored teenagers and general neglect hanging over the area. Threatened with violence and hounded out of the flats by the paranoid drug dealer 'Mongo', O'Halloran's Adam and the late Tom Murphy's Paul continue their city-wide, 'smack'-hunting odyssey. Never likely to feature in a tourist information guide, the Ballymun flats were an intrinsic part of Dublin's social history. Adam and Paul's vision of the city and its underclass is instantly recognizable to Dubliners and resonates with those who have experience of life in any major urban environment. ➥*Neil Mitchell*

(Photos © Patrick Swan)

*Directed by Lenny Abrahamson*
Scene description: Adam and Paul at the Ballymun Flats
Timecode for scene: 0:03:25 – 0:06:50

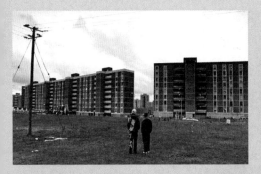 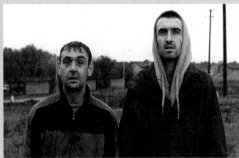

 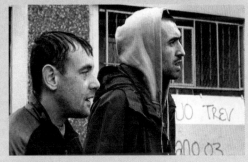

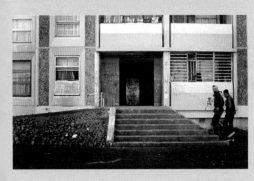 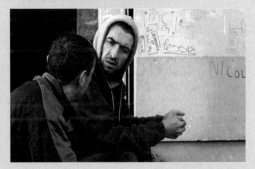

# INSIDE I'M DANCING (2004)

LOCATION *James Joyce Bridge and Mellows Bridge, River Liffey, Dublin*

**IN THE HEART OF IRELAND'S** capital city stands the futuristic James Joyce Bridge. Opened in 2003, it joins Dublin's South quays to the North across the River Liffey. A scene in *Inside I'm Dancing* shows palsy sufferer Michael (Steven Robertson) on the bridge, stricken, closely followed by similarly wheelchair-bound Rory (James McAvoy). Michael has moved from a stuffy care facility in the country into independent living in the city, attended by Siobhan (Romola Garai), an attractive live-in carer. When Siobhan discovers Michael's feelings for her, and it becomes clear he doesn't respect her boundaries, she takes her leave. Michael is deeply troubled by the sudden change and makes for the bridge. Rory catches up with Michael on the bridge, finally urging him to halt. A striking long shot of the bridge's sprawling illuminated bow arch represents the glittering independent future the boys had ahead of them. Their silhouetted figures glide across the bridge front. Rory threatens to throw himself off if Michael opts to return to the care home without him. Soaking wet, they turn towards Mellows Bridge along the Liffey, a symbol of the past, of their old life in care, where the bright lights of Dublin were far from view. Rory jokes that he should write a letter to Dublin City Council to complain that the barrier is too high for wheelchair users with suicidal tendencies to jump from. They are bound to the future, a brightly lit, exciting future born of the city in which they now live. ➻*Nicola Balkind*

(Photos © Patrick Swan)

*Directed by Damien O'Donnell*
*Scene description: Michael and Rory, upset, flee from home and meet on James Joyce Bridge*
*Timecode for scene: 1:18:14 - 1:21:00*

# SIX SHOOTER (2004)

LOCATION *Dublin-bound Dart, County Wicklow*

**AS WITH HIS CRITICALLY** acclaimed feature *In Bruges* (2008), Martin McDonagh's Oscar-winning short film *Six Shooter* proves that the Dublin demeanour is a movable feast. En route home from a rural hospital, Donnelly (Brendan Gleeson) has lost his wife, a mournful neighbouring couple (David Wilmot and Aisling O'Sullivan) have lost their baby, and a young, hilariously smut-mouthed Irish boy (Rúaidhrí Conroy) stirs the pot. Aboard the Dart train headed back to Dublin, the three sets butt heads in this thick atmosphere of grief penetrated by sharp, peat-black Irish comedic moments. Interspersed with shots of the lush green countryside, their claustrophobic vessel becomes an uncomfortable urn of mixed emotions. To break from this terse turbulence, Gleeson finally takes the boy up on his offer to tell his 'Story of the Cow with Trapped Wind'. This fantastical break, one of McDonagh's specialities, transports us to a cattle fair on the Wicklow coast. Farmhouse ruins stand in solidarity against a verdant coastal field, where the boy is seen wide-eyed and marvelling at a cow which swells with the strain of trapped gas. In voice-over, his thick Irish enunciation similarly bulges and bloats with anticipation, a classic pastoral mode of storytelling overtaken by excitement. At the climax, his tone veers to a conclusive temper as the cow, matter-of-factly yet spectacularly, explodes into the air, its spoils splattered across the grass. 'Best day of me fuckin' life, that cow exploding.' You can take the players out of Dublin, but you can't take Dublin out of the players.
**⇥ Nicola Balkind**

(Photo © Margaret Clough)

*Directed by Martin McDonagh*
Scene description: Flashback – kid's cow with trapped gas story
Timecode for scene: approx. 0:17:00 – 0:20:00

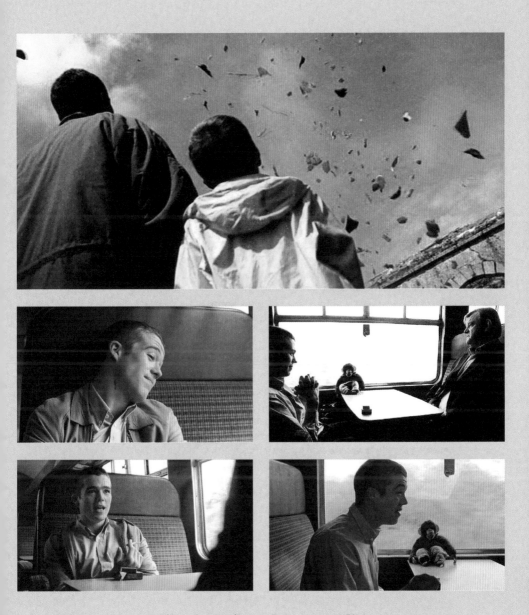

Images © 2004 Missing in Actions Films/Funny Farm Films/Fantastic Films in assoc. with Film4

# BREAKFAST ON PLUTO (2005)

LOCATION *Powerscourt Waterfall, County Wicklow*

**NEIL JORDAN'S** *Breakfast on Pluto* is set amid the rural periphery of Dublin and is centred on Patrick 'Kitten' Braden (Cillian Murphy), a decidedly different member of 1970s Irish culture. Abandoned by his glamorous mother early in life, the colourful transvestite grows up in the Catholic constrictions of Bray, County Wicklow. When turned away from a local club, Kitten leaves town in a swirl of colour with a pout and the puff of a fur scarf. He escapes prying conservative eyes with a motorbiking glam rock band, who take to 'The Astral Highway', parking their bikes amongst the roots of trees beneath the striking Powerscourt Waterfall, some fourteen miles south of Dublin. A crane shot envelops the cascade as the colourful crew huddle around a fire amongst the trees. Smoking in the foreground, their musings by the refuge of the gentle stream are far from rock 'n' roll, creating a serene tableau. Although the location is evocative they speak of reaching another place somewhere in the beyond – seeking their 'Breakfast on Pluto'. Though set beyond the boundaries of Dublin, there is a certain sense of camaraderie among these outsiders which serves to emphasize the city sensibility. Rather than gathering around a table at a pub, pints in hand, their taking to the countryside complements the overall character of the group and its congregation outside of the mainstream. Though their minds and words search beyond borders, their solidarity against the norm and against conservative Catholic homogeneity is an incidental act of patriotism.
**⟶ Nicola Balkind**

(Photo © David Staincliffe)

*Directed by Neil Jordan*
*Scene description: Kitten and friends smoke and drink by Powerscourt Waterfall*
*Timecode for scene: 0:20:55 – 0:23:04*

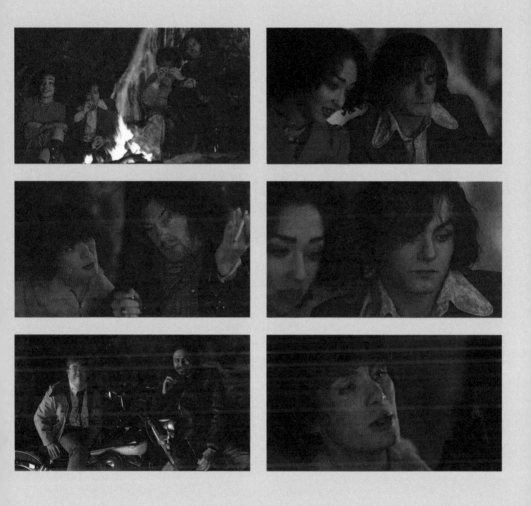

# PAVEE LACKEEN:
# THE TRAVELLER GIRL (2005)

*Carroll's Irish gift shop on Westmoreland Street, Dublin 2*

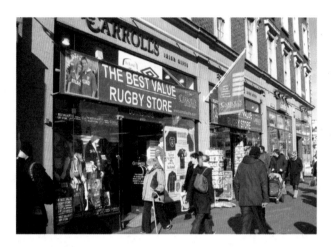

**PAVEE LACKEEN: THE TRAVELLER GIRL** is an episodic exposé of the plight of Ireland's travelling community struggling to exist in the teeth of the Celtic Tiger prosperity. It focuses on one family living in the docklands waste ground of Dublin's Ringsend area, specifically following 10-year-old Winnie (Winnie Maughan), one of ten children, as she roams the city centre during a week when she has been suspended from school for bad behaviour.
Her trips into town take in a series of middle-class shopping haunts: one selling New Age gifts, a video rental store, a bridal gown hire shop and a hair salon, all of which emphasise how marginalised she is from society. She wanders into a gift shop, one that trades in the sort of stereotypical, ersatz 'Oirish' paraphernalia designed to appeal to the passing tourists. A loud, cheesy rendition of *The Irish Rover* blares out as she enters the shop, a suitably artificial (and ironic, given the film's focus on travellers) soundtrack for an establishment dealing in the assorted orange, white and green novelty hats and shamrock-encrusted souvenirs which fill the collective shop front that Dublin shows to its visitors. Except visitors like Winnie aren't welcome; her attempt at shoplifting results in capture. The scene encapsulates the modern day traveller experience in Ireland; shut out and kept apart from, but ultimately controlled by, a society that has come to exert its identity through gaudy materiality and a cultural approximation of itself. **↔Jez Conolly**

(Photo © Eric Jones)

*Directed by Perry Ogden*
**Scene description:** *Winnie shoplifts fudge from an Irish gift shop*
**Timecode for scene:** *1:11:22 – 1:12:22*

 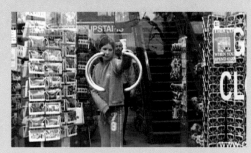

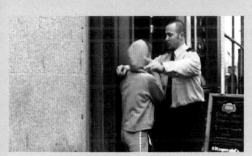 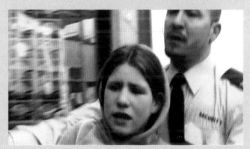

# ONCE (2006)

LOCATION

*Grafton Street, by an alleyway. Chases as far as HMV then back up to St. Stephen's Green (North entrance by the arch)*

**SET IN MID-NOUGHTIES DUBLIN**, *Once* traces the life of aspiring musician, Guy (Gren Hansard), and his growing affection for an immigrant, Girl (Markéta Irglová), through their mutual love of music. The film delves directly into Dublin's outdoor music scene, opening with handheld shots of Guy performing with an acoustic guitar for passing shoppers and tourists on Grafton Street. Guy has chosen a spot near a darkened, graffiti-decorated alleyway, attracting the attention of a drunken, homeless man. Their proximity to Dunnes Stores, Ireland's own chain of home stores highlights a tough truth about Dublin's distribution of wealth. The vagrant ostentatiously ties his shoes beside the guitar bag, throwing Guy off his rhythm. Diverting Guy's attention by throwing him some coins, he turns before quickly grabbing the jingling bag and making off down the street. Guy gives chase, entrusting the possession of his guitar to a kindly stranger as he races down Grafton Street, through a music shop, to St. Stephen's Green archway. When both are out of breath, the homeless man falls to the floor. Together they pick up the money whilst arguing about their mutual need for cash: 'If you need some money, just ask for it,' says Guy. It transpires that they know one another as the homeless man asks after Guy's mother. This strange familiarity, with its intrinsic desire for civility, is mired by desperation for necessities and feels distinctly Irish. In a big city, those at the bottom of the food chain must share but need to keep a little for themselves. **➻Nicola Balkind**

(Photo © Patrick Swan)

*Directed by John Carney*

**Scene description: Opening scene – Busker Guy chases a homeless addict who steals his case and money**

**Timecode for scene: 0:00:00 – 0:03:31**

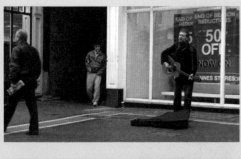 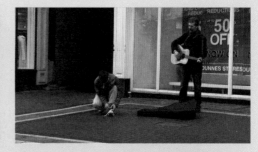

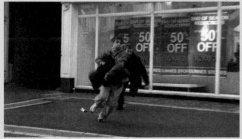 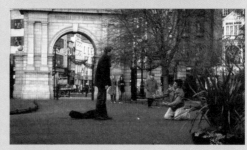

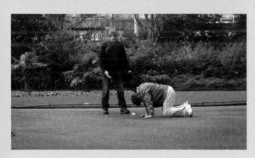 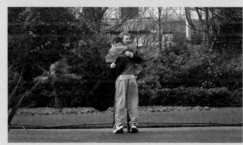

# THE FRONT LINE (2006)

LOCATION *Moore Street open air fruit and vegetable market, Dublin 1*

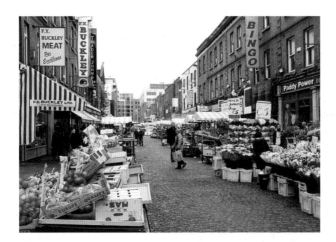

**CONTRARY TO THE LONG-OBSERVED** historical tendency among the Irish people towards widespread emigration, a characteristic of Ireland's recent boom years has been a sharp influx of immigrants from many parts of the world into the country, and especially into Dublin. As has been the case in numerous other cities in Western Europe over the equivalent period, the experience of many of the migrants looking to settle has been fraught with insecurity and a lack of acceptance by the indigenous community. The experience of Congolese refugee Joe Yumba (Eriq Ebouaney) in David Gleeson's polemical heist movie *The Front Line* proves to be especially hazardous when he unwittingly gets caught up with Dublin's underworld. Before his circumstances become precarious there is a brief scene shot at Moore Street Market shortly after Joe's wife and son have joined him in Dublin on a family reunification visa. The market is a Dublin institution; it is the city's oldest open market where today its combination of traditional fruit and veg vendors and Asian, African and East European supermarkets make for a bona fide melting pot. Wandering past the stalls Joe's son stares blankly at a lively tabletop display of wind-up toys, his young mind diverted by the cultural trauma of his new surroundings. Joe's wife spots a silver ethnic necklace on another stall. Amid Dublin's unfamiliarity it triggers a warm memory of home, and Joe proudly places it around her neck. Their new world will come to offer them precious few moments of such intimacy. •*Jez Conolly*

(Photo © Marek Slusarczyk)

*Directed by David Gleeson*
**Scene description: *Joe's family at Moore Street Market***
*Timecode for scene: 0:13:30 – 0:14:58*

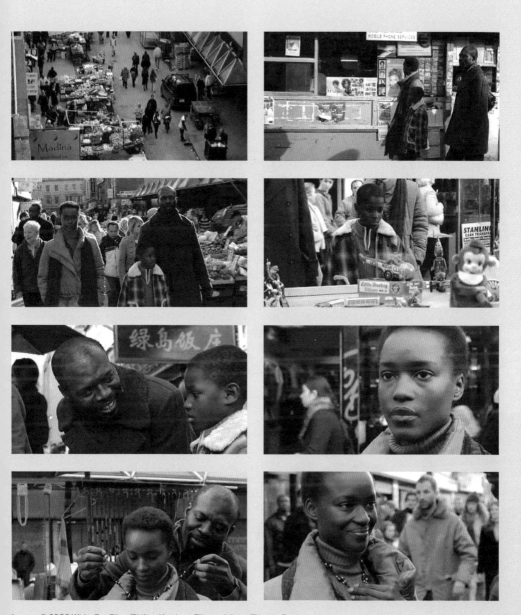

# CRAICING THE SAFE

Text by CLAIR SCHWARZ

## *The Gangster Figure in Dublin Cinema*

**CINEMATIC REPRESENTATIONS** of the city of Dublin are, like any other mediated concepts, subject to the weight of preceding constructions which create the image of the city within the national and global imaginary.

Films which engage with the theme of organized crime exhibit the tensions specific to Ireland and Dublin, negotiating with and struggling through the various pushes and pulls of the past and present. The gangster genre has a relatively short history within Irish cinema. Not until *The Courier* (Deasy and Lee, 1988) did a cycle of films emerge which negotiated the themes of organized crime in a recognizably generic fashion, adhering to the codes and conventions of the gangster film. Along with the Western, the gangster genre epitomizes the Hollywood style, and any appropriation of the genre by another place, whether Dublin, Paris, London or elsewhere is always subject to a comparative exercise, evaluating one text by what it is not, as well as what it is. If then, the Dublin-based film evokes other places, such

as Chicago by way of Hollywood, how does it create its own sense of place?

Starring Gabriel Byrne, *The Courier* utilized the city as a physical and metaphorical staging of the struggles of economic growth, crime and modernity, utilizing the conceit of proliferation, whether high-rise architecture or heavy traffic to suggest an increasingly urbanized conurbation. The problems of progress were also present in *Taffin* (Megahy, 1988) released in the same year. This film explores the tensions between the country and the city, where a village located outside of the city is threatened by invading developers. This Gaelic take on *Seven Samurai* (Kurosawa, 1954) sees a single man (Pierce Brosnan) hired by the community to save them from such corrupting development.

However, in 1994 the murders of the Dublin gangster Martin Cahill (aka The General) and the investigative journalist Veronica Guerin reinvigorated the gangster genre, hybridizing it with the conventions of the biopic and/or the 'based upon' text. Thus, *The General* (Boorman, 1998), *When the Sky Falls* (Mackenzie, 2000), the BBC television film *Vicious Circle* (Blair, 1999), *Ordinary Decent Criminal* (O'Sullivan, 2000) and *Veronica Guerin* (Schumacher, 2003) were made and released within ten years of their deaths.

The figuring of Dublin in *Veronica Guerin* is predicated upon a binary coding which situates the social divisions evident in the city between those who enjoy success and social integration and who live in the green rural outskirts of the city, and those marginalized and exploited residents of urban Dublin. Thus, the concrete square around which the destitute corporation flats are arranged is littered with the detritus of intravenous drug use, but devoid of any green, the chromatic indicator of Irishness. Yet washing still hangs

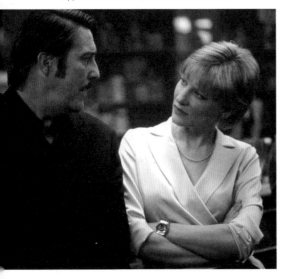

to representations of not only a figure drawn from real life and the whole problematics of the biopic, but also the nature of cinematic representation itself. John Boorman's film *The General* engaged with the mythic, presenting Brendan Gleeson (as Cahill) as an archetype of Celtic mythology. Indeed, Boorman's utilization of the maze-like topography of Dublin's alleyways as a means for the 'minotaur' General to evade the pursuing Gardaí illustrates his employment of a mythic sensibility.

A later rendering of the same displaced subject of Cahill saw a very different approach. Thaddeus O'Sullivan's *Ordinary Decent Criminal* displaced the figure of Cahill onto the Hollywood star Kevin Spacey, attracting much opprobrium for such a seeming absence of authenticity (O'Sullivan is not precious about adhering to the authentic, as illustrated through his utilization of Dublin as a stand-in location for Belfast for another loyalist 'crime' film *Nothing Personal* [1995] a fictionalized rendering of the Shankhill Butchers). Yet, O'Sullivan's film is more concerned with the playfulness of postmodernism. In this sense, the casting of Spacey as Michael Lynch is explained as a continuation of performance for an actor fêted for his bravura role of 'Verbal' Kint in *The Usual Suspects* (Singer 1995), interestingly, alongside Gabriel Byrne whose role in *The Courier* started the whole ball rolling.

The casting of an American as a fictionalized Irish gangster can be seen as a development of Irish cinema inasmuch as it addresses the very globalization which both challenges and supports its various identities, opening them up to a more nuanced view than the standard stereotypes offered through the limitations of a cinema of heritage. Moreover, the suggestion of a generalized uniformity to the issues and problems caused by illegal drugs and the criminality involved, whether that be the gin joints of prohibition Chicago or heroin use in the corporation flats of 1990s Dublin, indicate the historical and geographic continuation of the dynamics between the exploiters and the exploited. The adoption of imported generic conventions of another country's cinema is an indicator of the adoption of the means of exploitation. Gangster flicks follow gangsters' tricks. ✦

in the drizzle, indicating an unseen domesticity. It is in one of these flats that the horror outside is physically and psychically internalized as a fictionalized Cahill tortures a naked man, his nakedness redolent of a crucified Christ. In contrast to the grey of the urban, the suggested instigator of Cahill's murder, John Gilligan, a 'small man with a chip,' is shown accessing respectability through social climbing, achieved through the accumulation of land where he breeds race horses. The luxury (and ostentation) of his home and well-furnished stables stands in stark contrast to the resulting deprivation which provides his wealth. A later scene historicizes the notion of consumption and exploitation. Here a meeting between Guerin and her double-crossing informer at the port shows the river as the conduit of drugs into the city, reversing the direction of the diasporic movement away from the home country in Ireland's past. Here, in a horrible irony, it is consumption rather than famine which is killing Ireland's children.

Cahill is an interesting cipher for a discussion on the different approaches

**Films which engage with the theme of organized crime exhibit the tensions specific to Ireland and Dublin, negotiating with and struggling through the various pushes and pulls of the past and present.**

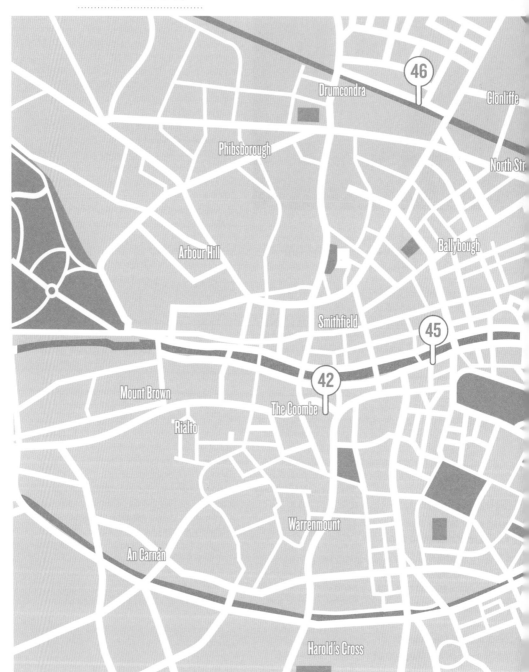

# LOCATIONS
## SCENES 40-46

# THE TIGER'S TAIL (2006)

*U2 Tower construction site, Dublin Docklands*

**JOHN BOORMAN'S** prescient *Prince and the Pauper* reworking is set, as the title suggests, during the tail end days of Ireland's Celtic Tiger boom. At that time, and still to this day despite the economic nosedive, the skyline of Dublin was dominated by the looming construction cranes responsible for the characterless glass and steel new-builds which periods of prosperity bestow upon modern cities. The film's opening sequence shows ruthless, wealthy property developer Liam O'Leary (Brendan Gleeson) stuck in traffic amid the remains of a day that will culminate in him receiving an Irish Enterprise Award at a prestigious black tie dinner. We see repeated shots of the cars around him creeping slowly forwards, set against the troubled dusk of a Dublin evening and the silhouettes of the stilled cranes planted in the Docklands area. The scene is punctuated by O'Leary's first sighting of a have-not *doppelgänger* – his twin brother it transpires – a rough and ready roadside squeegee merchant who briefly obliterates the view of the skyline with a soapy sponge on O'Leary's windscreen. The cranes that represent O'Leary's entrepreneurial success seem now almost to be stalking him and there is the sense that this stream of traffic is a tributary leading inexorably towards the river, where his dreams and ambitions – as well as those of the other business people alongside him in their expensive cars, stressed and struggling to hold on to the last vestiges of the boom years – will surely sink as the attendant cranes look silently and solemnly on. **❖ Jez Conolly**

(Photos © Patrick Swan)

*Directed by John Boorman*
**Scene description: Dublin's construction cranes in the dying days of the Celtic Tiger**
**Timecode for scene: 0:00:20 – 0:04:10**

Images © 2006 Fern Gully Tales/Merlin Films

# 32A (2007)

*Dollymount beach at the end of the Wooden Bridge in Clontarf*

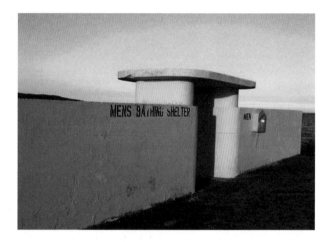

**32A IS A COMING-OF-AGE** film telling the story of four teenage girls living on the Northside of Dublin in a middle-class suburb during the 1980s. The main character, Maeve (Ailish McCarthy), is going through puberty and all it entails, experiencing the changes in her body and awakening sexual interest in boys. The film gets its name from the first bra size of the main character, which she proudly sports in her school's locker room with much admiration from the other girls. 32A also happens to be the number of the bus route from town to Raheny, the suburb in which these girls live. This early scene is a typical depiction of teenagers on the brink of maturity, hanging out in a public place, whiling away the time discussing the meaning of life. In this instance, the girls cycle across the famous wooden bridge in Clontarf that links the main road to the causeway of Bull Island and Dollymount Strand, two to a bike. Cut to the girls hanging out in one of the concrete shelters sporadically dotting the beaches of Dublin, newly painted and looking fresh. While the girls comment on life and love and as yet unknown husbands and babies, beneath the surface deeper emotional issues are churning. A piece of nostalgia for Northside grownups who remember the first of many snogging sessions at the infamous Grove disco, the film gives a view of a more comfortable Northside Dublin than that depicted in the works of Roddy Doyle. **⇢ Díóg O'Connell**

(Photo © Sarah Gallagher)

*Directed by Marian Quinn*
Scene description: *Four friends hang out discussing life on Dollymount beach.*
Timecode for scene: *0:11:32 – 0:13:00*

# BECOMING JANE (2007)

*Mother Redcap's Tavern, Christchurch, Dublin*

**DUBLIN STANDS IN** for London in this formative story of Jane Austen's life, a production decision based on the similarity of County Wicklow's unspoilt countryside to the landscape of Austen's day. In a very un-Austen-like scene we meet Tom Lefroy (James MacAvoy), who is to become Jane's (Anne Hathaway) love interest in the film, engaged in a pugilistic duel in a distinctly seedy boxing club, which has the atmosphere and clientele of a disreputable tavern, replete with drunken revellers and ladies of ill repute. The Dublin live music venue and bar Mother Redcap's Tavern doubles for the real Gentleman Jackson's Fight Club, which was in Bond Street, London. The location is suitably cavernous and dingy; awkward filming angles lend an authenticity to what was as much a part of the London of Austen's time as the more genteel environments she would have visited when in the city. The exterior of the club was shot in North Great George's Street in Dublin, convincingly doubling for Georgian London with appropriately dim lighting and dangerous street life. The scene leads directly to, and contrasts nicely with, a brief exterior that introduces us to Tom's respectable life as a trainee barrister. Filmed in Dublin at King's Inns on Henrietta Street, the location deputizes for London's law courts, embodying solid establishment values in the stone architecture and pavements. The ease with which Tom, as a man, can negotiate both these worlds contrasts vividly with the constrained lives of women in Austen's day.
**•• David Bates**

(Photo © Patrick Swan)

*Directed by Julian Jarrold*
**Scene description: Tom Lefroy boxes at Gentleman Jackson's Fight Club**
**Timecode for scene: 0:07:56 – 0:09:33**

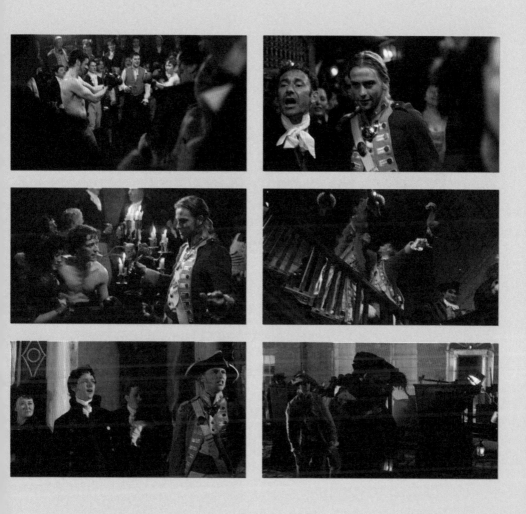

# KISSES (2008)

LOCATION *Dublin's Grand Canal*

Two fearless, hard-faced children jump on a trash-dredging canal boat motoring slowly towards Dublin city. The craft is skippered by a kindly Eastern European (David Bendito) who entertains them, keeps them warm and escorts them into the city. The moment has shades of *Huckleberry Finn*. But in what Kylie (Kelly O'Neill) and Dylan (Shane Curry) are escaping from, the scene resonates with the fairy tale horror of Charles Laughton's 1955 masterwork, *The Night of the Hunter*, in which two children seek delivery from evil in a mythic boat journey. In Lance Daly's film, Kylie and Dylan are escaping from the wastelands of West Dublin's neglected housing estates. Emotional and physical abuse festers openly like a sore. Sexual abuse is just an arm's reach away. The film reflects this domestic depravation by being captured in brutal black and white, turning the rubbish-strewn, squalid suburbs into jagged high-contrast. With a wad of Christmas cash from Kylie's uncle, the children's dream of escape becomes real and the film blooms into colour. Dublin's Grand Canal becomes the great deliverer. But the promise of a fairy tale leads instead to the grim reality of danger and despair. Daly taps into a primal power, the taboo of targeting children and Dublin's underworld becomes the hunter. The city, awash in the festive blur of Christmas lights, becomes a wilderness where the children must live off their wits and the occasional kindness of strangers. •**Paul Lynch**

(Photo © Patrick Swan)

*Directed by Lance Daly*
**Scene description: Children travel on a canal boat**
**Timecode for scene: 0:16:16 – 0:24:44**

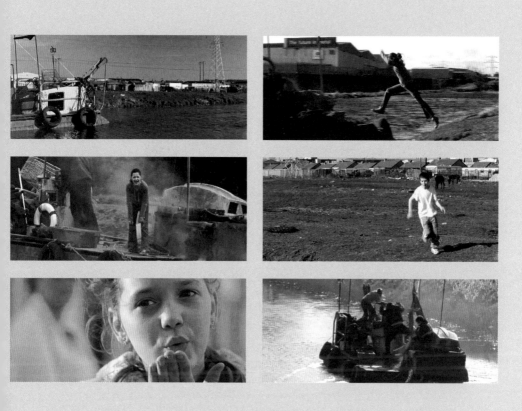

# PERRIER'S BOUNTY (2009)

LOCATION *Ealing and Acton, West London, UK*

**ACTOR/DIRECTOR** Ian Fitzgibbon's crime comedy *Perrier's Bounty* may be set in modern day Dublin but its familiar narrative positions the city as a Wild West town where crime is rife, the local law ineffectual and problems are solved at gunpoint. The vision of the city, where its gangsters, drug dealers and loan sharks habitually use abandoned warehouses and industrial estates as the sites of criminal activity, is largely fabricated for a variety of reasons. Shooting locations, soundtrack, script and genre tropes all combine to create the milieu of this 'urban Western' that in actuality bares little resemblance to Dublin, socially or geographically. The second scene in 'Delgado's Pool Hall' encapsulates the constructed identity of the city for *Perrier's Bounty*, with its mainly interior setting, actual shooting location, use of music and narrative nods to the Western genre. This sequence, like the majority of the movie, was shot in and around Ealing Studios, London, with interiors and exteriors standing in for Dublin. As David Holmes's funk/rock soundtrack kicks in, reminiscent of 1970s American crime thrillers, all hell breaks loose in the seedy pool hall. A volley of verbal abuse, bullets and bloody violence erupts in a clear homage to the Western genre's good guys versus bad guys saloon bar shootouts. Viewed in isolation this scene is a straightforward action set piece, but within the overall narrative it represents (with its regional accents, colloquialisms and familiar cast faces) the heart of the fictional Dublin being portrayed; that of a lawless, dangerous and openly violent city. •**Neil Mitchell**

(Photo © Peter Jordan)

*Directed by Ian Fitzgibbon*
**Scene description:** *The shootout at Delgado's Pool Hall*
**Timecode for scene:** *0:52:02 – 0:55:54*

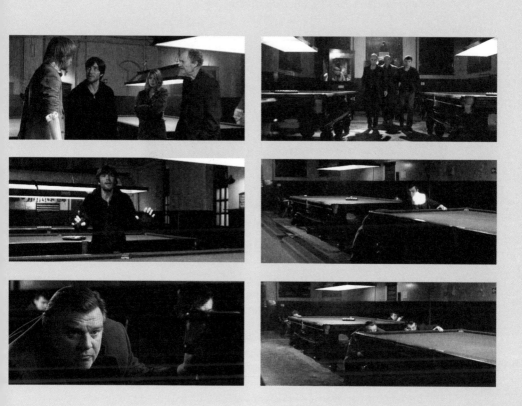

# SAVAGE (2009)

LOCATION *From Temple Bar along Georges Street and Wexford Street to Protestant Row, South Bank, Dublin*

**BRENDAN MULDOWNEY'S** disturbing tale of masculinity in crisis is set in a modern Dublin, and has an unflinching eye for those aspects of any major city which we would prefer to ignore. The scene preceding Paul's (Darren Healy) devastating assault starts with a romantically framed shot of him with the young nurse Michelle (Nora-Jane Noone), two young people on the verge of a love affair, embracing as they are silhouetted against the lights of the city and evening traffic. Paul takes his leave and walks home through the town, lost in a reverie about the girl he is just getting to know. His dress and demeanour speak of a confident Irish culture entirely at home with a newfound prosperity. As his walk continues, however, we notice with him that the dark side of Ireland's boom has heightened the divide between the moneyed elite and the life that finds its expression in the bars and cheap alcohol this city offers. Paul, a freelance news photographer, is confronted by street level despair and aggression without the filter of his camera to give him distance. The streetlights, which framed him so flatteringly, now spare him no detail of the human detritus of the city. Dublin here stands for any prosperous metropolis in the western world. If the energy and enterprise of the Celtic Tiger economy are apparent in Paul's lifestyle and the youthful and bustling bar he was in a few minutes before, then the scenes we witness through Paul's eyes are equally a consequence of the now-ended economic boom. ➺**David Bates**

(Photo © Patrick Swan)

*Directed by Brendan Muldowney*
Scene description: Paul's walk through drunken Dublin street-life ends in a horrific assault
Timecode for scene: 0:09:00 – 01:11:30

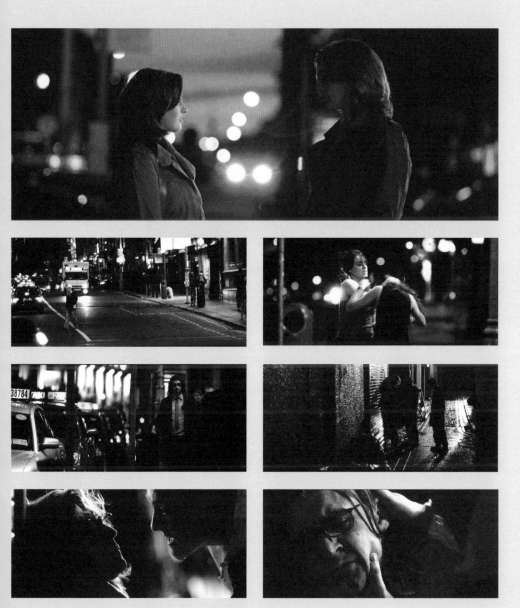

Images © 2009 SP Films

# BETWEEN THE CANALS (2011)

LOCATION *North inner city, Dublin*

**BETWEEN THE CANALS** tells the story of three small time hoodlums over a particularly busy St. Patrick's Day. The film's title relates to the inner city boundaries of the Royal Canal on the Northside and the Grand Canal on the Southside. The depiction, however, is confined to scenes of urban deprivation and decay, a small section of the varied urban landscape between the canals. Many Irish films of the past fifteen years have focussed on criminal urban male youth, tying them to US and British popular culture. *Between the Canals* centres on the redemptive story of one character, Liam (Dan Hyland) who is seeking to change his life, put his criminal past behind him, become an electrician and provide for his girlfriend and small baby. This he plans to do after one last day of criminality, and so unfolds the circular road movie around the confined streets of Dublin's inner city. This scene depicts Liam caught up in an all-too-familiar gangland shooting in an urban working-class pub. Retrieving the gun he had just handed over to the victim before he was shot, he makes his escape and casually disposes of the weapon in a dumpster in the middle of a council flat complex. Despite the ubiquitous nature of such cinematic depictions, this scene, through its link to a later scene when a young boy comes across the gun, is powerful in its subtle suggestion of the dangers and devastation of crime when it gets rooted to inner city communities. **⊷Dióg O'Connell**

(Photo © Peter Gerkhen)

*Directed by Mark O'Connor*
**Scene description: Gangland shooting in an inner city Dublin pub**
*Timecode for scene: 0:45:00 – 0:46.39*

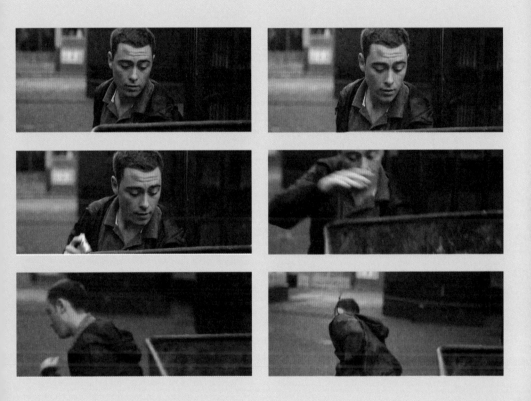

# MIDDLE-CLASS AND PROUD OF IT?

Text by
STEPHEN
BOYD

*Representations of Dublin
during the Celtic Tiger Era*

**IF CINEMATIC DEPICTIONS** of Dublin in the 1990s were dominated by the portrayal of the North West inner city and the apparently happy-go-lucky nature of its working-class inhabitants, encapsulated by The Barrytown Trilogy of *The Commitments* (Parker, 1991), *The Snapper* (Frears, 1993) and *The Van* (Frears, 1996), then the cinema of the Celtic Tiger has been a wholly different affair. These new representations of Dublin, stemming from roughly the year 2000, depict a dichotomy between a new affluent urban middle-class, and conversely, the social decay and outsider lives of those left behind by the economic boom of the 1990s and 2000s.

A number of films have reflected the recent prosperous nature of Dublin City. Among the most notable were the romantic comedies, Gerard Stembridge's *About Adam* (2000) and Kieron J. Walsh's *When Brendan Met Trudy* (2000), and Stephen Bradley's

horror-comedy *Boy Eats Girl* (2005). In all three films, Dublin takes on the role of a city at ease with its new comfortable middle-class identity; a perspective that journalist Brendan O'Connor noted at the time had traditionally been a 'shameful secret' in home grown depictions of Ireland. Indeed the novelist and scriptwriter of *When Brendan Met Trudy*, Roddy Doyle, stated that he provided the film its middle-class setting because it reflected Dublin more accurately in the 2000s. However it is the micro budget feature *Goldfish Memory* (2003) directed by Liz Gill that attempts to present the Dublin urban landscape from a completely new perspective. Although low budget digital filmmaking in an Irish context is conventionally associated with a greater cinematic realism, *Goldfish Memory* takes Dublin's new cosmopolitan ambiance and transforms it almost to the realm of fantasy. From the opening picture postcard establishing shots of the River Liffey, Gill utilizes a range of city centre locations such as galleries, coffee shops, bars and restaurants in new urban developments in order to portray a city which is youthful, vibrant, economically self-sufficient and sexually liberated. Dublin itself becomes the generic international stylish city, mimicking the urban enclaves of New York, London or Paris, and the imagery in the film is not dissimilar to that of the Dublin tourist board.

However, there have been extremely contrasting representations of Dublin throughout the course of the Celtic Tiger. John Boorman attempted to warn his audience of the social problems left behind by the greed and excess of the Celtic Tiger in his

allegorical thriller, *The Tiger's Tail* (2006), and many other film-makers turned their backs on Dublin's supposed affluence in order to depict a city and its people who did not benefit from the economic boom of the period. Low budget features such as Lenny Abrahamson's *Adam & Paul* (2004), and the photographer Perry Ogden's *Pavee Lackeen: The Traveller Girl* (2005) could be described as holding an altogether more prescient viewpoint of Dublin given the recent economic downturn in the Republic of Ireland. In *Adam & Paul*, the darkly comic story of two wandering drug addicts, Dublin becomes a city of backstreets, alleyways and dereliction as Abrahamson and writer/star Mark O'Halloran attempt to portray those people and places that were ignored by social and political policy throughout the richest era in the history of the Irish State. Abrahamson and O'Halloran again tackled the issue of social exclusion in their four part television series, *Prosperity* (2007) which focused on characters such as a Nigerian asylum seeker and a teenage single mother. In *Pavee Lackeen*, Perry Ogden focuses on another social group for whom 'out of sight, out of mind' appears to have been a government mantra throughout the Celtic Tiger: the Irish travelling community. Ogden is also known in Ireland for his photography project 'Pony Kids'

**Dublin itself becomes the generic international stylish city, mimicking the urban enclaves of New York, London or Paris ...**

which represents the horse culture in the working-class suburb of Ballymun, itself an area of urban regeneration in the Celtic Tiger years. Just like in Ogden's photography, *Pavee Lackeen* blurs the line between fiction, documentary realism and social realism in that the Maughan family, whose lives the film depicts, were untrained actors and real members of the travelling community, including its young star, Winnie Maughan. Ogden uses the industrial location of Poolbeg in Dublin's docklands to represent the social periphery of Dublin to which Winnie and her family have been pushed – an area lacking basic amenities. In a scene in the latter half of the film, Winnie takes a tour around the new Celtic Tiger Dublin encountering a Russian video shop and a Nigerian hairdresser in the north inner city. She then stands outside a bridal wear shop staring at the people within in a scene which the director employs as analogy; Ogden clearly implies that Winnie, and others like her, are the metaphorical outsiders from the wealth of the New Ireland.

Perhaps the most inspired film to emerge from the tail end of the Celtic Tiger was Lance Daly's *Kisses* (2008), a tale of two children who run away from their bedraggled Dublin suburb and their own personal trauma to take a magical realist journey into Dublin city centre via the Grand Canal and an eventual encounter with Bob Dylan. Daly's films, such as *The Halo Effect* (2004) and *Last Days in Dublin* (2001) employ many central Dublin locations and allow them to be seen as both real and unreal; a Dublin of the imagination which provides a welcome impressionistic perspective of the capital city during the Celtic Tiger.

If any film encapsulated modern Dublin cinematically during boom years it was John Carney's Oscar-winning musical romance, *Once* (2006), in which the city itself becomes a character. From its dingy bedsits to Grafton Street, the glitzy main shopping thoroughfare, *Once* attempts to paint Dublin as a whole, rather than simply through the narrow lens of class distinction. For this reason, *Once* can be viewed less as a product of its time and environment, but rather as a possible vision for how Dublin will come to be framed in future Irish cinema. ✦

# GO FURTHER

*Recommended reading, useful websites and film availability*

## BOOKS

**Irish National Cinema**
By Ruth Barton
(Routledge, 2004)

**Keeping it real: Irish film and television**
By Ruth Barton and Harvey O'Brien
(Wallflower Press, 2004)

**Historical Dictionary of Irish Cinema**
By Roderick Flynn and Patrick Brereton
(Scarecrow Press, 2007)

**The Myth of an Irish Cinema:**
**Approaching Irish-themed Films**
By Michael Patrick Gillespie
(Syracuse University Press, 2008)

**Border Crossing:**
**Film in Ireland, Britain and Europe**
By John Hill, Martin McLoone
and Paul Hainsworth
(Institute of Irish Studies in association
with the University of Ulster and the
British Film Institute, 1994)

**The Cinema of Britain and Ireland**
By Brian McFarlane
(Wallflower Press, 2005)

**Irish Film: The Emergence of a**
**Contemporary Cinema**
By Martin McLoone
(British Film Institute, 2000)

**New Irish Storytellers:**
**Narrative Strategies in Film**
By Díóg O'Connell
(Intellect, 2010)

**Screening Ireland:**
**Film and Television Representation**
By Lance Pettitt
(Manchester University Press, 2000)

## BOOKS (CONTINUED)

**Cinema and Ireland**
By Kevin Rockett
Croom Helm (1987)

**Imagining the Modern City**
By James Donald
(Minneapolis: University of Minnesota
Press, 1999)

## ONLINE

**Come Here To Me!**
www.comeheretome.wordpress.com

**Darklight Festival**
www.darklight.ie

**Dublin Film Critics' Circle**
www.dublinfilmcriticscircle.weebly.com

**filmbase**
www.filmbase.ie

**Film Ireland**
www.filmireland.net

**Irish Film & Television Network**
www.iftn.ie

**Irish Film & TV Research Online**
www.tcd.ie/irishfilm

**Irish Film Board/Bord Scannán na hÉireann**
www.irishfilmboard.ie

**Irish Film Institute**
www.irishfilm.ie

**Irish Film Portal**
www.irishfilmportal.blogspot.com

**Jameson Dublin International Film Festival**
www.jdiff.com

# CONTRIBUTORS

*Editor and contributing writer biographies*

## EDITORS

**JEZ CONOLLY** holds an MA in Film Studies and European Cinema from the University of the West of England, and is a regular contributor to *The Big Picture* magazine and website. Jez comes from a cinema family; his father was an over-worked cinema manager, his mother an ice-cream-wielding usherette and his grandfather a brass-buttoned commissionaire. Consequently, he didn't have to pay to see a film until he was 21, and having to fork out for admission still comes as a mild shock to this day. After many years soaking up anything and everything on-screen he started to exercise a more critical eye in the 1980s, became obsessed with David Lynch movies and grew a goatee beard to give him something to stroke when patronising art house cinemas. The rest is cinematography. In his spare time he is the Arts and Social Sciences & Law Faculty Librarian at University of Bristol.

**CAROLINE WHELAN** is a freelance writer and researcher. Past career highlights have included putting the white bit on Sooty's wand at a toy factory. Studying creative writing has led her to stalking people for 'inspiration' and eavesdropping in cafes. She could go on about her Dublin ancestors, but she won't.

## CONTRIBUTORS

**NICOLA BALKIND** is a freelance film journalist and web content producer based in Glasgow, Scotland. She holds a BA (Hons) in Film and Media Studies, and is currently writing her MLitt in Film Journalism at the University of Glasgow. As well as contributing to *The Big Picture* magazine and regional press, her thesis on anthropomorphism in animation entitled *Animation and Automation* was recently published by Film International. Nicola is also Web Editor of the Channel 4 branded website *Quotables* (powered by Mint Digital), and Web Editor of Edinburgh International Film Festival. You can find Nicola online at *nicolabalkind.com*.

**DAVID OWAIN BATES** spent his childhood on a Carmarthenshire farm, has looked after children with learning disabilities in Bristol, worked as a chef in a Chinese restaurant in West Wales and run a pub in South London. He has worked in a dot-com company at the height of the boom, where he drank a lot of the venture capitalists money in the finest bars in Soho and lost his job in the crash. He has been involved in an international charity start-up and solved more computer problems and server crashes than he can recall. One day he will decide what he wants to do when he grows up but until then is dealing with an addiction to DVD box sets and a love of the darkened dream world of the cinema, where he mutters darkly about safety lights ruining the magic. He wants to live in the Everyman in Hampstead.

**STEPHEN BOYD** is a lecturer in Film, Media and Cultural studies at the Institute of Art, Design and Technology (IADT) in Dun Laoghaire, Co. Dublin, and a Ph.D. student at Trinity College, Dublin. His specialist area of study is Irish Cinema.

**SCOTT JORDAN HARRIS** is the editor of *The Big Picture* magazine. He writes for *The Spectator* and co-edits its arts blog, and is a contributor to many magazines, websites and journals, including *Film International*, *Fangoria* and *Rugby World*. He has also written for several books on cinema, including the London, Dublin and LA volumes of the *World Film Locations* series. His blog, ➜

# CONTRIBUTORS

*Editor and contributing writer biographies (continued)*

A *Petrified Fountain*, was named one of the world's twelve best movie blogs by *RunningInHeels.co.uk* and can be viewed at *www.apetrifiedfountain.blogspot.com*.

**CHIARA LIBERTI** is an independent film critic, film curator and programmer, living and working between Ireland and Italy. Fundamentally, and entirely, devoted to the art and circulation of films, she has obtained a BA in Film Studies at the University of Bologna and curated an extensive film season on Contemporary Irish Cinema at the Film Institute of Bologna in 2008. She has recently completed an MA in Curating Visual Arts at the Dun Laoghaire Institute of Arts, Design and Technology, and has collaborated with the Irish Film Institute in Dublin. She is programme advisor at the Irish Film Festa of Rome.

**PAUL LYNCH** is a writer and critic living in Dublin. He was the chief film critic of Ireland's *Sunday Tribune* newspaper from 2007 to 2011, when the newspaper collapsed. He is a member of the Dublin Film Critics Circle and served on the juries of the Jameson Dublin International Film Festival in 2009 and 2010. He is a regular contributor to RTÉ Radio, Today FM and Newstalk and has just finished writing his debut novel, to be published in 2012. At the time of writing, his favourite film is *Vertigo*.

**COLM MCAULIFFE** has worked in programming and editing for the primary film festivals in Ireland since 2006. He has also written and lectured extensively on film and literature, written and produced a number of plays which have performed both in Ireland and Off-Broadway and his

current research interests include dissenting Irish Literature, Critical Theory and Cultural Studies. Prior to this he languished in obscurity in Cork and Dublin before suffering a dramatic nervous breakthrough in New York which propelled him to his current heights.

**NEIL MITCHELL** is a freelance film critic, writer and editor based in Brighton, East Sussex. He graduated as a mature student from the University of Brighton with a BA in Visual Culture. Having contributed to various editions of Intellect's *Directory of World Cinema* series, he has taken on the role of co-editor for the British volume. His interest in all aspects of cinema has led to a growing fascination with British cinema in particular, which led to him editing the London volume of the *World Film Locations* series. He writes regularly for *The Big Picture* magazine, *The Spectator*'s arts blog and RogueCinema.com, and occasionally for VariedCelluloid.net and *Electric Sheep*. He can be found most days tweeting about film and other cultural matters on @nrm1972.

**ADAM O'BRIEN** is a Ph.D. candidate at the University of Bristol, where he also teaches. He is currently studying New Hollywood cinema and its ecological/eco-critical dimensions.

**DR. DÍÓG O'CONNELL** lectures in film and media at Institute of Art Design and Technology in Dun Laoghaire, Co. Dublin. Her book *New Irish Storytellers: Narrative Strategies in Film* was published by Intellect Press in 2010 and she is co-editor of *Documentary in a Changing State*, Spring 2011. She has written extensively on Irish cinema in books, journals and magazines.

**CHRISTOPHER O'NEILL** has contributed to several film-related magazines (*Film Ireland, The Dark Side*), websites (*Senses Of Cinema, Experimental Conversations*) and is currently writing a book on London's much-missed Scala Cinema which was located in King's Cross from 1981 to 1993. He has been active in many areas of the British and Irish film industry including cinema programming and booking (Kino Cinema in Cork City, Ireland), theatrical distribution (Soda Pictures, London) and general freelancing in these areas. Beyond cinema exhibition Christopher is also a film-maker who has written, edited and directed short films such as *Saint Francis Didn't Run Numbers*, which is part of the Irish Film Institute's touring experimental cinema programme, *Absences and (Im)Possibilities*.

**CLAIR SCHWARZ** is currently studying for a Ph.D. at the University of the West of England. Her thesis concerns the work of the British film-maker Shane Meadows, and is entitled *Shane Meadows: Representations of Masculinity, Class, and Liminality* (due for submission summer 2011). She teaches various courses on film and visual culture at UWE and supervises third year dissertations. Her particular interests are representations of masculinity in film, feminist theory and approaches and British cinema. She has been published in *The Journal of British Cinema and Television* and is awaiting the publication of a chapter on Shane Meadows in a forthcoming collection. Her paper, 'An Object of Indecipherable Bastardry: Homosociality, Homoeroticism and Generic Hybridity in *Dead Man's Shoes*' was originally presented at a conference dedicated to the director held by the University of East Anglia (April 2010). The edited collection of papers is due to be published by Manchester University Press at a future date.

**LISA SHAND** is a freelance Creative Director working in television. Most recently she spent a year at Virgin Media as TV Brand Manager. Prior to that she worked as a consultant on projects including a digital pre-launch campaign for Shane Meadows's 2009 film *Le Donk & Scor-zay-zee* and prior to that she worked for Red Bee Media on the launch of BBC iPlayer. Lisa is also the creator/author of *Pigeon Blog*, an award winning character-based blog starring an urban pigeon called Brian. *Pigeon Blog* has appeared in *The Times, The Guardian*, the *London Evening Standard*, Radio 5 Live and, in 2008, was voted in the *Time Out* Top 10 London websites. She has written freelance articles for various magazines and is in the middle of her first novel. She is also a published photographer and has exhibited work in London, Oxford and Brighton. Lisa is currently developing *Pigeon Blog* for television.

**PATRICK SWAN** is a professional photographer based in Dublin, Ireland. His award-winning landscape photography spans four continents and has a distinctive formalist approach. He also shoots weddings, portraits, events and technical subjects with an interest in high-speed and high-dynamic range photography. Patrick is also Art Director for the creative communications company Mindmap and an impassioned cineaste.

# FILMOGRAPHY

*A comprehensive list of all films mentioned or featured in this book*